RAVE ART

FLYERS // INVITATIONS AND **MEMBERSHIP CARDS**
FROM THE BIRTH OF **ACID HOUSE** CLUBS AND **RAVES**

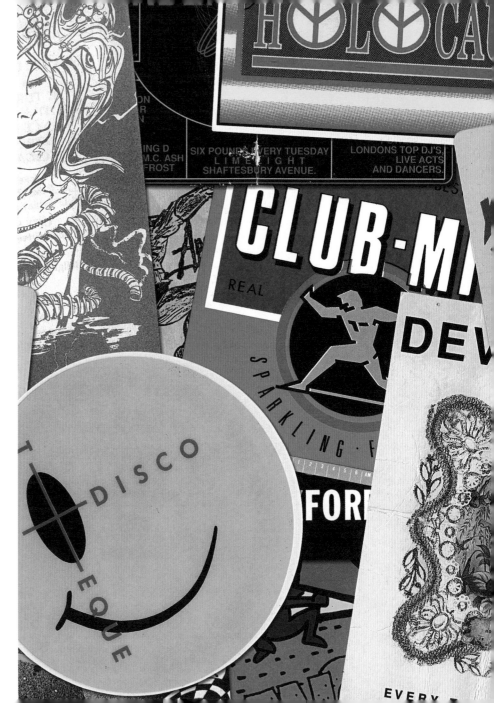

THIS IS A CARLTON BOOK

Published in Great Britain in 2014 by
Carlton Books Limited
20 Mortimer Street
London W1T 3JW

Text copyright © 2014 Chelsea Louise Berlin

Design copyright © 2014 Carlton Books Limited

A CIP catalogue for this book is available from the British Library.

Editorial Manager: Roland Hall
Design: Russell Knowles
Production: Rachel Burgess

ISBN 978-1-78097-595-5

Printed in Dubai

10 9 8 7 6 5 4 3 2 1

RAVE ART

FLYERS // INVITATIONS AND **MEMBERSHIP CARDS**
FROM THE BIRTH OF **ACID HOUSE** CLUBS AND **RAVES**

CHELSEA LOUISE BERLIN

FOREWORD // **MARK MORE**

CARLTON
BOOKS

//CONTENTS

192 // TRACKS THAT MADE THE PARTY JUMP // **CHELSEA LOUISE BERLIN**

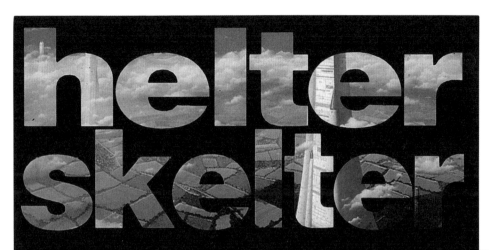

helter skelter

"OUTER LIMITS" "NEW WORLD" PUMPHOUSE PRODUCTIONS"

proudly present

THE GREATEST DANCE MUSIC SPECTACULAR EVER APPEARING FOR ONE NIGHT ONLY ON

30th SEPTEMBER 1989
AT THE
HELTER SKELTER
DANCE MUSIC FESTIVAL

Featuring from the USA

● **CE CE ROGERS** — performing Someday, Forever
● **KLF** — performing 3am, What Time Is Love
● **KARIYA** — performing Let Me Love You For Tonight
● **LIL LOUIS** — performing French Kiss
● **LOLLETTA HOLLOWAY (Black Box)** — performing Ride On Time, Love Sensation
● **TWO IN A ROOM** — performing Everybody In The House Say Yeah
● **JOMANDA** — performing Make My Body Rock
● **THE MINUTEMEN** — performing OK Alright, Bingo Bongo

● **SHA LOR** — performing I'm In Love
● **CORPORATION OF ONE** — performing The Real Life
● **BAS NOIR** — performing My Love Is Magic, I'm Glad You Came To Me
● **RALPH ROSARIO** — performing I Want Your Love

And from the UK

● **PAUL RUTHERFORD** — performing Oh World
● **JOLLY ROGER** — performing Why Can't We Live Together
+ SPECIAL GUESTS

DJ/PRODUCERS TO COMPLIMENT MARK MOORE, EDDIE RICHARDS, KID BATCHELOR, JAZZY M, FRANKIE BONES, ROMAN RICARDO, FREDDY BASTONE, NORTY COTTO, MICKY 'HOT MIX 5' OLIVER.

Artiste and Music Programming by Vito Bruno, Tim Taylor & Colin Davie.

★ FULL CONTINENTAL THEME PARK ★ INTERNATIONAL CRAFT FAIR ★ ZOOM RECORD MARKET ★ THAI BARBECUE ★ CHILLOUT CAFE ★ NUMEROUS SIDE SHOWS AND STALLS ★ SUPERIOR QUALITY TURBOSOUND SYSTEM ★ MULTI-COLOURED LASERS ★ FREE CAR PARK ★ MEDICAL STAFF IN ATTENDANCE ★ HEATED COVERED SITE ★ LICENCED AND LEGAL

BLACK MARKET 25 D'Arblay St, W1. RED RECORDS 47 Berik St W1, Tel. 01-274 4476, 500 Brixton Rd, SW9, Tel. 01-734 9746. ODDBALLS 136 Hoxton St N1, Tel. 01-739 3698. VINYL ZONE 112 New Kings Rd, W2, 01-3842 320. SOUL II SOUL The Basement 162 Camden High St NW1, Tel. 01-267 3995. MUSIC POWER 37 Grand Parade Green Lane N4, Tel. 01-800 6113. TRUMP RECORDS 188 High St Ruislip, Tel. 0895-635507. RECORD VILLAGE 256 Hoe St E17, Tel. 01-520 7331. G M RECORDS 302 Elephant & Castle Shopping Centre SE1, Tel. 01-708 0988. REVOLUTION RECORDS (Slough) 7 St Leonards Rd, Tel. 0753-867291. CRASH MUSIC CO (Leeds) 35 The Headrow, Tel. 0532 465823/0539 436743. PINK MOON Acorn Gallery Newington, Tel. 051 709 4819. LOADING BAY RECORDS (Birmingham) 586 Bristol Rd, Tel. 021 472 9463. Mail-Order — Tel. 0612 362555/2577. PICADILLY RECORDS (Manchester) Tel. 0612 362555/2577. DREAMTIME PROMOTIONS (Bath Bristol & West Country), Tel. 0860 448919. VICTORIA TICKETS (All Areas), Tel. 01-8280084. FINBAR (Edgware) Tel. 01-906 2183. KEVIN (Reading) 0734 789953. MAXINE (Brighton) Tel. 0273 27857. JO (Milton Keynes) Tel. 0908 314746. BRENDON (Luton) Tel. 0582 495534. KEITH (Maidenhead) Tel. 062 8895538. GARY (Essex) Tel. 0691 857677. JOE (Feltham) Tel. 0831 490 730. CHALKY (Banbury) Tel. 0295-271190. TRACE (Portsmouth) Tel. 0892 545203. GEOFF (St Neots) Tel. 0480 219196. FLIP (Essex) Tel. 0402 754806.

No membership or tickets on sale after 28th Sept. Discount on tickets before Friday 22nd September.

This event is a private party for Helter Skelter members and their guests only, membership and tickets are available solely from appointed agents. Beware of forgeries. Over 18's only.

//FOREWORD

Do you remember a time before the internet? I tell you there was such a time, it's true. It was a world where we had nothing to do. Nothing at all, so we went out dancing all night, the lot of us. Sometimes it was all night but sometimes for two or three days. It was a time when organising a party wasn't as simple as doing an event invite on Facebook or casually clicking 'send' on an email to all your contacts and cyber-pals. These, my dear friend, were the days and nights of a thousand flyers handed out by real live people either in a club, in a street, after a rave, or cluttering up the tables and shelves at your local record shop.

 You would come home in the morning (or afternoon) and empty out your pockets stuffed full of the things. Some were expertly designed by real artists. Some didn't even bother with artistry; a cheap bit of paper with the name of the venue and an allusion to good times and dancing with maybe a few disco biscuits crudely drawn on, the whole creative process taking about five minutes. Other flyers were pasted and glued together much in the spirit of punk rock that had come before.

 We all had the fever. Hooked by the music and helped along with a little bit of you-know-what (is he talking Lucozade?) It was non-stop partying, we were loved up and we loved it. "Don't give up your day jobs!" they said at Shoom, because let's face it we were ready to change both ourselves and the world; getting carried away was an understatement. The flyers in this book perfectly capture the times leading up to, during and beyond the Second Summer of Love which brought forth those trippy acid house nights that we thought were never going to end. And in a way they never have.

Mark Moore
(www.markmoore.com)

//RAVE, HOUSE AND THE ART OF THE FLYER

BY //CHELSEA LOUISE BERLIN

I've been collecting ephemera and items from my travels and clubbing days for as long as I can remember. Magazines, flyers, programmes, comics, postcards, tart cards, you name it, if it is of interest, aesthetically pleasing, a reminder of something I've done or been to or seen and adds content to my visual library, I keep it.

You can imagine then the joy I got from being a regular club attendee in the mid- to late-1980s with my posse: Marc S, Lance J, Nigel C (RIP), Richard G, DJ Frankie G, Tom Z, Hilary, Helene, Rick W, Matt and Mick R (RIP), with the plethora of new events and parties that started appearing with the new music arriving from the States, and being brought back from the summer events in Ibiza. Those parties were the forerunner to the hugely notorious 'Acid House' and 'Rave' scene.

The associated hand-outs, invitations and flyers to promote those events that let us in to fantastic new avenues of experience also provided me with an amazing, growing collection of new visual fodder.

Being a regular at many clubs and events when I was still at art school in the mid-1980s, and going on to then exhibit my artwork at London galleries, as t-shirts across the city in numerous retail outlets as well as in *The Face* magazine and as banners at Philip Salon's 'Opera House' nightclub in 1987 (after meeting him at his infamous 'Mud Club' parties), gave me the opportunity to get to know and hang out with people from the music and DJ world who would become good friends.

Eric Robinson (MCA and 'Good Good Feeling'), Mark Moore (DJ and soon to be UK chart number one artist with his S'Express band), the singer Marilyn, club and scene regulars Winston, Stephen H and Eddie Armani (from Tina Turner's band) were fellow night owls, hanging out in the back and VIP rooms at Heaven, Delirium, the Mud Club and the Library at Limelight. (*See* page 31)

Those friendships enabled me to listen to the newest tunes coming in from the US, original Acid and House anthems, and to get invites to some of the newest and most interesting, on-the-pulse underground events that were springing up across London at the time, providing me with what was to become the start of my invites and flyers collection.

The invites would come to us sometimes when we were still in the clubs, most often when we were leaving in the early hours, on occasion just by passing by someone or standing with them in the cloakroom queue and getting into a conversation, but practically all the invites were in the form of printed flyers of one medium or another: Paper ones, plastic ones, fabric ones, laminated or even edible ones on the odd

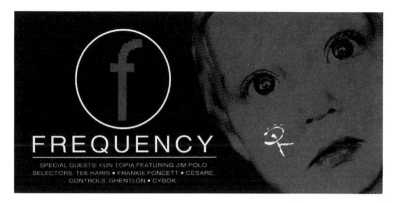

RIP/ FREQUENCY
//June 1988 // Paul Stone & Lu Vukovic // Clink Street, London SE1

occasion (they haven't survived in good enough condition for this book alas) but of every shape, style and genre you could think of.

For a few years my main posse of friends had for the most part been fly girls and b-boys. The hip-hop scene had been on top for some time, VW and Mercedes automobile insignia were de rigueur, MA1 flight jackets, DM shoes, Adidas sneakers, over-sized t-shirts, trappers' hats or baseball caps was our look, and beat box, rap, bass beats and drum loops our sounds, filling our senses and driving our feet.

1988 was arguably hip-hop's greatest year, with bands like Run DMC, Eric B and Rakim, Public Enemy and the Jungle Brothers having their biggest albums and most regular airplay; and we were lapping it up thinking nothing could be better.

Clubs like Crazy Larrys, Discoteque, the Café de Paris, Mud Club/Busby's, Browns, Soul II Soul's Sound Clash and Paramount City were our regular haunts, and we would listen to the best beats by the best DJs, including Paul Trouble Anderson, Jay Strongman, Fabio and Grooverider, Fat Tony, Jazzie B and Norman Jay.

In the background, however, there was a change going on in clubland that had started in 1987 and was progressing at a fantastic rate, and we were all getting totally caught up with it. (*See* page 36)

Tracks we had been introduced to in late '86 and through '87 from a different genre of bassline-led music playing at 120BPM known as "Acid House" and originating out of The Warehouse, a gay club in Chicago, started to take over the dance floor.

With its main practitioner the late great Frankie Knuckles, who with Jamie Principle created the anthem 'Your Love/Baby Wants To Ride', artists like Steve "Silk" Hurley whose 'Jack Your Body' was the first house number 1 in the UK in 1987, Larry Heard, Raze, Phuture, Dancer and Marshall Jefferson, were taking over the clubs' turntables and sound systems and house music from the hip-hop based sounds we had been listening to. It was new, pulsing, deep, driving and electric, and was having a big influence on clubland and beyond.

The new music was soon to spawn changes not only to what we were listening to in the clubs but also to the social, youth, music and fashion movements that crossed borders, racial and economic divides that had previously been a prevalent negative force in "Thatcher's Britain".

Jazzie B of the collective Soul II Soul and Norman Jay were heavily involved in these changes on a music and fashion level. After spending a year or so outside the West End promoting their Sound Clash sound system events, they moved into central London with their now legendary parties at the Africa Centre between 1986 and 1988. There, they created a distinctive UK sound, mixing soul and reggae and giving opportunity for a much more mixed audience of black and white kids from all backgrounds, actively encouraging them to party together. (*See* page 25)

It was, however, Danny and Jenni Rampling and Paul Oakenfold, whose respective clubs opened late in 1987 (Klub Sch-oom, soon to be renamed Shoom in a dance studio in Southwark and Future, in the back room at Heaven in Charing Cross), that really turned us all on to "Acid" and "House" music on a daily basis.

As has been well documented, Joe Smooth's house anthem 'Promised Land' summed up the feelings of many of those on the scene and especially at those clubs, where ecstasy taking, wild dancing and smiley people, who would otherwise and in different circumstances (violence was escalating at football matches at this point for example) have been at each other's throats, found 'love': Hugging each other, stranger to stranger, in an ecstasy-induced euphoric state.

And it was at Shoom – after it moved to the YMCA on Tottenham Court Road and then on to Busby's – that those from completely opposite sides of the tracks would be seen and heard, singing the words of the song together, forgetting their differences;

'…like angels from above/come down and spread their wings like doves…'

Causing a roadblock outside the venue after it ended, they joined those who had not been able to get in, partying and dancing in the street until the next morning.

But it was in early 1988 when Hedonism and RIP began their parties at the defunct prison on Clink Street (now a museum and famous tourist trap), that my best early memories of the new euphoria sweeping through clubland came from.

It was with the words of Mr. Fingers/Fingers Inc's track 'Can You Feel It' that the communal spiritual reverence of this new found "house music" swept us up off our feet and to fantastic new places.

"IN THE BEGINNING THERE WAS JACK…"

At the start of the song as the beat starts pumping, a preacher narrates the introduction, ending with "And house music was born."

As soon as the track started the entire thronging mass of people would take on the reverential aspects of the words as if they were in their very own spiritual church, and like a gospel congregation would be uplifted as one. We were for all intents and purposes in our very own "house" of prayer…

RIP and Hedonism's mix of house and acid music and open door policy helped pull everyone together, turning those clubs into pumping sweat-boxes, with condensation running off the walls (due probably to the heat coming off the hundreds of people dancing for hours on end) in a labyrinth of unheated, rotting rooms. (*See* page 44)

It was also the first time I saw people using 'window panes'. Window panes were acid/LSD that came in a gel tab form that would be put directly into the eyes like contact lenses, melting straight through the iris to the brain, changing eye colours to lurid greens, reds and blues. It was a truly surreal sight watching clubbers happily and crazily finding their way around the club with luminous vibrant eyes and staring, smiley gazes, as if summoned to prayer by their own personal deity.

1988 was also the year I went to my first Mutoid Waste party. Put on in the grounds by a collective of squatters in King's Cross, they had taken over a huge tenement block at the back of the mainline station on Battle Bridge Road and turned it into what seemed to me at the time a utopia of artisans, creatives and other-worldly beings. (*See* page 43)

To gain entry to the party you got in to the back of a disused and derelict coach partially outside the grounds, scrambled down inside to the front doors, and exited through them directly into the event itself. It was a cross between a Mad Max movie-set and a dance club, with scrap metal sculptures, walls of tyres, fire bins and spinning

elements all over, and an incredible treat for the senses, mind and soul.

It was the first of a couple of events of theirs I went to that year, all of which were as good if not better than the last. It culminated in their participation at Metamorphosis II's New Year's Eve party at the Academy Wastelands in SW9, which had their 'Timezone' clocks across the venue ready to chime in the new year. (*See* page 58)

By mid '88 'smiley culture' and the iconic smiley face emblem which has become its symbol couldn't be missed, and the common call of "Aciieeed" and "where's the acid house party?" could be heard and seen everywhere, from pirate radio stations to magazines, t-shirts sold on every street corner from Camden Market through the West to Brick lane in the East of London and far beyond.

My posse and I spent most weekends starting at Club Trick and MFI at Legends in Old Burlington street and The Limelight on a Thursday/Friday and Saturday night, and thanks to the lovely Denzil on the door we were all sure to get a queue jump and squeeze. (*See* page 46) Club Trick and MFI were, as far as I was concerned, the best two clubs around at the time. We would dance and party with some of the beautiful people, rubbing shoulders with the great and good and not-so-good of the music and fashion scenes, (Leigh Bowery became a regular in his 'Pig snout', 'light bulb' or other incredible costumes) before leaving at 3am, flyer or invite in hand ready to head off to what was starting to become a regular jaunt out of the West End. We would travel either across town, North or East, or into the suburbs or often beyond, to continue in a warehouse or other commercial building tarted up and fitted out with huge amplified sound systems for the sole purpose of our continued hedonistic pleasure long into Sunday proper.

The flyer or invite was our key; it had directions to a meeting point or a phone (0898) number or pager number on it or a contact name. It was the key to finding, and then getting in to the event with or without paying... It definitely was a case of; "no flyer or invite, no ticket, no entry!" Of course, while going from one club to the other, I was keeping as many of these fantastic memory-inducing slips of card or paper or plastic as I could lay my hands on.

It was a truly exciting and inspiring time for most if not all of us, we really did feel part of something new and revolutionary and definitely illicit, which of course was half the fun! While the BBC banned Jolly Roger's 'Acid Man', the parties simply gained momentum and in August 1988 the unforgettable Apocalypse Now at Wembley Studios in Alperton started. This culminated, as far as I am concerned, in one of the best events of the era in September of that year, with a mega party running from Friday through to Sunday, with each hour in the venue getting better and better. (*See* page 53)

It was a night of crazy proportions... I remember at one point standing back from the main throng looking out across a sea of writhing bodies of all races, colours, creeds and persuasions, a coloured haze in the air. Looking up at the darkened roof of the building letting in tiny pinprick points of light, like stars, ecstatic and exuberant dancers on huge podiums writhing, gyrating and 'box' dancing. I vividly remember thinking I must be on the flight deck of some galactic *Star Wars*-inspired vessel in outer space, in the middle of an epic battle that conversely looked and felt like a huge love-in, then losing myself again in the music and vibe and dancing for hours.

I certainly had no idea where my friends had gone when I finally left the venue in daylight the next morning in a somewhat exhausted and wrung out state. What met my eyes was a sight I can tell you. People strewn all over the car park, St.John's Ambulance volunteers tending to some worse-for-wear souls and others still dancing around and about, their own personal DJ set ringing in their ears.

I had no idea where I was or how I would get home and off to see my father later that morning. I was lucky enough though to get chatting to a familiar looking guy I had been in the VIP room with who had come out of the venue around the same time as me.

It was Martin Fry of ABC, who very kindly offered me a lift (to coin a lyric from Soul II Soul) 'back to life, back to reality' and off to NW3 where I was living at the time.

From there I somehow managed to get out to Buckinghamshire to play tennis with my father while coming down off the influences. It was, as you can imagine, a rather surreal experience with all things taken into account.

My weekly, sometimes four-nightly, sojourn into clubland was supplying me with a plethora of opportunities not only to enjoy the wonderful music, people and fashion, but also to increase my visual library with the amount of and variety of invites and flyers available for all the new clubs and parties we were attending.

There were so many fantastic events being promoted, fanzines being handed out, and if you knew where to look and who to ask, from promoters and record purveyors like the guys in Black Market Records in Soho or 'Flying' in the now destroyed and redeveloped Kensington Market, you would have access to all of that, along with the latest 12-inch vinyl imports that were so very rare and highly sought after to boot.

I got to spend a lot of time with these new tracks as my friend Frankie G, who

had started building a fantastic collection of vinyl, would buy dozens at a time and spend hours making mix tapes for me and the posse between his work and his DJing. I still have 20 or more C90 cassette tapes with all the biggest tracks of those years tucked away at home.

By the end of 1988 Acid House had spread across the country, with Daisy in Liverpool, Trance in Cheltenham and Bounce in Northampton, and it wasn't long before my partying took me to areas far outside London and the M25.

I'd been going to Bristol regularly, every other weekend or so jaunts since mid-1987, to meet up with close friend Joe W and his crew; Janet and Lena P, Stewart and Vicky, Mickey, DJ Dommy T and his co-conspirator Grant, AKA Daddy G soon to be of Massive Attack and a whole crowd of welcoming West country people who were also finding the euphoria of the music and ecstasy and the scene.

It's easy to note from my nights at the Thekla, Dance studio parties and the Moon club in 1988, how the Rave and House music scene had arrived and influenced everyone, especially the soon-to-be international dance music acts, and what brilliant nights we all had down in Bristol.

Seeing Jolly Roger perform at the Moon Club alongside Dommy T and the Prime Time crew is not to be forgotten. The venue was rammed and we were crammed up next to the biggest bass bin I've ever seen and felt, but it didn't stop us as we danced non-stop for hours and got taken into new dimensions with A Guy Called Gerald's 'Voodoo Ray', one of the seminal tracks of the year if not the entire period.

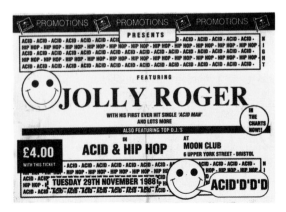

ACID & HIP HOP
// November 1988
// Featuring Jolly Roger
// Moon Club, Bristol

My first night at the Dance Studios for Get Digital with Dommy T and Daddy G DJing and MCing was legendary… I will never forget how amazing it felt when 100, or more, of us epitomized the euphoric and ecstatic feelings created with the music, drugs and desire for an evolving communal spirit when we spontaneously broke into a version of a House Music 'line dance/synchronized dance' to Raze's all time classic 'Break For Love'. It was definitely the song of the Bristol scene for many, certainly our posse at that moment in time. The overwhelming feeling from those nights was of a collective love for each and everyone. While that was in part down to the copious amounts of clear cap ecstasy taken by most of those attending the parties, there was also a genuine desire for something better for all of us to come out of the scene, not just financially (as seemed to be the sole motivator for the promoters), but spiritually and emotionally. People were really looking out for each other, not only at an event but were pro-active in their efforts outside of the parties. Those nights and the subsequent days in Bristol were fantastic, and it wasn't long before the Bristol posse and the London posse started mixing regularly, joining each other in their relative cities or at an event betwixt or between.

As the year ended Apocalypse Now became Sunrise, Fabio and Grooverider opened Rage and Genesis hit the scene with a terrific night in a warehouse in Aldgate in east London.

In November 1988 Sunrise's Guy Fawkes party was held in the derelict gasworks where *Full Metal Jacket* was filmed, and despite the police trying to close it down (now a regular occurrence) they were forced to withdraw due to the sheer scale of people who climbed fences and dodged them across main roads to get to the event. Sunrise sold 4,000 tickets to the party. Thankfully due to my step-brother Roger G who was working with the promoters we got in without too much hassle and as usual enjoyed a great night seeing little if anything of the ensuing mayhem outside, and by the time we left it had all gone quiet.

The *Daily Mail* reported a day or two later, the party was an 'evil night of ecstasy' which we simply had to laugh at. Of course there was ecstasy as well as other things, but it certainly was anything but evil! While there was a darker side to the parties, with football gangs trying to muscle their way into either security at the venues or a cut of the profits for them being held in their 'manor' (we later heard of the promoter of Labrynth, Joe Wieczorek, being held up by three guys with machetes), this is not something we were aware of at the time. Our sole interest,

and that of most people we met was to party, dance, and generally get out of it for as long as possible, looking out for each other and not doing harm to anyone else. We were very much caught up in this new and quite monumental movement that was changing the face of youth culture. It felt great (in hindsight) to be part of a scene that was to forever change popular music, dancing, watching and listening as dance music become the definitive and driving force in the industry.

In early 1989 the scene took on another new direction. With so many inner city clubs having short licencing hours, and with the police crackdown on anything in an unlicensed venue and warehouse, the promoters and organisers simply couldn't take the risk of an event not happening or being able to cater for the amount of people wanting to participate, so they took their events to the countryside. There, they had more space to operate and it was harder for the police to get in the way, so very soon we became nomads of the M25!

There were Sunrise, Biology, Energy, Back to the Future, Weekend World, World Dance and many other parties and events every weekend, sometimes more than one a night, all vying with each other to be known as the biggest and the best, each new event being touted as the greatest show on earth! (*See* page 86)

Most, if not all, of these parties had the most fantastic top DJ line-ups. They had incredible live acts from the US or UK, fairground rides, bouncy castles, thousands of kilowatts of sound, lasers and sometimes tens of thousands of people dancing in a field, farm outbuilding, aircraft hanger, car park or other remote venue.

It is around that time that the parties were given a name and known as 'Raves' and in turn, we were being called 'Ravers'. The definition of a rave is:

"An all night event where people go to dance, socialize, get high and generally have fun, listening to a distinctive set of repetitive beats."

One of the most fun (usually) aspects of getting to a rave was the way it all happened. I have mentioned earlier in this text how we would leave a venue in the early hours of the morning, already high on energy and partying for the last few hours in the West End, to be handed a flyer or invite to what was, until the very last minute before the rave actually started, a closely guarded secret venue somewhere (usually) outside the centre of London.

Meeting points for the raves would be made available through the invites and flyers, in some cases newsletters sent out to members in advance of a rave or handed out on the night at a club. Often it would be through adverts sent out on the airwaves via the pirate radio stations, Sunrise, Force or Fantasy, or updated regularly on the club promoters' information lines whose numbers were on the invites or flyers. (*See* page 90)

While mobile phones were still regarded as yuppy toys, the messaging services available made them an easy and ideal way to get people coordinated to different meeting points (the corner of a country lane, petrol service station or outside a phone box), where some guys in a hoody or baggy top and trousers, Kickers and a bandana, would check your credentials and check you weren't undercover police.

I actually got asked the following more than once: "What are you looking for, have you got an invite?" and "Are you on one yet?"

If it was all ok and you were legit, you'd get sent off in the right direction until you couldn't mistake where to go, from the light show and thumping music getting closer and closer, often glimpsed through a hedgerow or a fence onto an industrial estate or other commercial building. It was often simply a case of "follow the car in front", and more often than not a large convoy of 20 or more cars would arrive in tandem from any direction at any one time.

Keeping the venue secret and advertising solely with invites, flyers and on pirate radio, the promoters could keep everyone guessing where the party was until such time as they had either sent the police on a wild goose chase, or were happy enough they weren't around to simply send everyone where they needed to go.

More than once we had to go on a big diversion away from a party to make sure the police didn't get to it and close it down before we all arrived.

In the end this meant that thousands of people could all descend on a field or a venue in the middle of nowhere in a short space of time making it literally impossible for the police to do anything other than look on inanely. It was exactly due to this cloak-

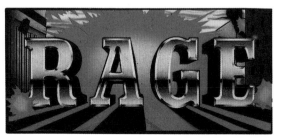

RAGE
// November 1988
// Fabio and Grooverider present // Heaven, Villiers Street, London WC2

and-dagger type of movement to get to a party that we eventually ended up in a cattle silo, dancing halfway up a 30-foot pile of cattle feed, after a Back to the Future party had to be moved when the original venue was discovered at the last minute one night in April 1989. (*See* page 90) As usual the party went on, and then on and on, and over the next few months promoters started to further try to outdo each other in one way or another with bigger and better or more outlandish venues, sites, guests, performers, lighting rigs and visuals. If you could name it, they would try it.

The Once in a Blue Moon Sunrise 5000 event in May 1989 was held in an aircraft hanger at Santa Pod race track. Although, legend has it this almost didn't take place as there was no electricity or toilets when the crew arrived and they only managed to make good and carry on with a dangerous diesel generator and a lot of finger crossing. It turned out yet again to be a party to remember, with Little Louie Vega DJing along with Paul Trouble Anderson and Evil Eddie Richards.

It was however soon to be outdone by the next Sunrise party, the Midsummer Night's Dream in June, held at the White Waltham airstrip in Berkshire. It is reported there were 11,000 people there, although to me it felt like it could have been double that. (*See* page 96)

It was one of those incredible nights (and mornings) when you completely lost yourself in music, beats and a communal euphoria. The DJ line up was outstanding, including Judge Jules, Trevor Fung and Paul Trouble Anderson and the MC was Mr. C (of The Shamen). With the DJs playing the best music you could hope for, the lasers superb and the people so genuinely elated, it beggared belief how there was any trouble anywhere in the world despite the papers (the *Sun* especially) trying to suggest we were all so high we were killing pigeons! We weren't of course… Their lurid insinuations were just lies to spark public opinion and sell papers, but what else could you expect from the British press? What youth movement hasn't upset the status quo?

It was also in May of 1989 that Energy by way of Karma Productions, who had been holding parties at Fun City in Soho to great applause, got in on the act with their first major warehouse event. Surprisingly not in a field in the countryside, but in Westway film studios in Shepherd's Bush in central London. This was to be a party that would set new levels of production and arguably be the precursor to the super clubs' lay-outs when they would arrive in due course.

Five rooms, a dozen DJs, a Greek temple, a *Blade Runner* room, and this was

only the start. You could get lost for hours just trying to navigate from one place to the other, although it really didn't matter if you did, or separated from your posse – no-one seemed to care about much other than dancing and getting high and sharing the love. The overwhelming memory of the event was the unity of all mixes of people once again, something rarely seen in the clubs before this time with their strongarm and picky door policies, but this event really was a terrific melting pot and left a lasting impression on many.

Energy 2 was held in a field in Membury, Berkshire, and although the police sealed off 20 miles of the M4 it didn't seem to stop anyone getting there and for us, meeting Denzil on the gate with his usual open arms and guest entry was a very welcome sight. A great start to the evening and morning's party after a long and arduous journey to get to the rave. This was another fantastic event, bouncy castles, fairground rides, huge trailers covered in hay bales that afforded a place to dance, snooze or whatever else people got up to on an "E"… (*See* page 87)

I have very vivid memories of doing some convoluted version of a barn dance to Doug Lazy's 'Let It Roll' with Frankie G and Helene as the sun was coming up, and seeing Mick R on top of one of the hay bales, Mohawk silhouetted by the sun, giving it his all as he always did.

Yet this was nothing compared to the next Energy party we attended soon after Biology's party in a field near Elstree Studios in Hertfordshire in June. The Karma Productions guys had managed to get a warehouse behind Heston Services, off the M4, to hold what they said would be a spectacular party. We had been at MFI at Legends as usual and with invite and pager had headed off to the west of London with all the details we needed, or so we thought. Unbeknown to all of us and thousands of other ravers and vehicles, the police had sent 1,000 officers to seal off the entire area, hoping to put the promoters out of business and us out of sorts. As we got closer and closer to the venue and the service station we realized every off ramp and exit had been blocked off in both directions. So, along with hundreds if not thousands of other ravers, all of us drawn to the thumping beat of the house music on the far side of the service station, we simply parked our cars on the hard shoulder of the motorway, ran down the inside of the crash barriers, through the service station forecourt, under, over or through the fence and hedges at he back of the plot and into the industrial estate containing the warehouse where the rave was located.

It was amazing, an adrenalin and ecstasy-fuelled night, which, due to the

excessive size of participation the police simply had to let happen and did nothing other than make sure people left the next day. We partied all night and came out in the sunlight to find the car where we left it without even a parking ticket attached, and went home exhausted but happy. (*See* page 118)

———

Along with the changing, daring and more incredibly staged parties, there was also a change in fashion over the year. From what had been mostly market based and high street hoodies, bandanas, baggy tops and trousers, with the obligatory fluorescent yellows, greens and pinks, UV receptive designs and colours, the popular hippy-come-club chic, tie-dye South American bringhomes and Thai and Balinese batik clothing, there was the "never-seen-without" bum bag and for many a baby's dummy (used to help with the chewing sensation caused when taking ecstasy), there was the introduction of a smarter, more fashionably astute clubber-come-raver, wearing more designer and specialist club wear. This would include brands such as: Timberland, (white) Levi's, silver foiled and highly decorated t-shirts by Nick Coleman and Australian label Mambo, a return to Katherine Hamnett designs and slick dresses in clingy fabrics, smarter high top trainers by Nike or biker boots and designer backpacks.

There was also a profound change in the flyer and invite being handed out to the regular (and other) raver and clubber. What had originally been hand drawn and written single colour flyers, created using basic and cheap one or two colour high street print firms, was replaced with a highly stylised, artist generated, multi colour print on good quality paper with vivid pictorial images and clever use of abstract and unique designs or well known artists' work. The most popular of whom was Keith Haring, whose work could be seen most notably on the Dance Party and Method Air flyers. (*See* page 100)

But it was Karma Productions with their Energy and Fun City parties who created in my opinion the best and most dazzling invites and flyers from mid-1989 onwards, using what looked like computer-generated images, slick metallic lettering and glossy finishes. (*See* page 149)

Solaris, with their members' newsletters, slick flyers (including Kimoto and Underwater) and fashion label through Nick Coleman were the precursors to Karma Productions' excellent invites and flyers, and also gave us our almost weekly Sunday afternoon chill down venue and after-rave come-down party from mid-1988 onwards. Held in the back rooms of an almost hidden venue in Grays Inn road In King's Cross/Holborn, Solaris was a members-only club, with juice bars, salad bars, chill down zone and slightly muted yet still happening

tunes played from Sunday lunchtime until late in the evening. They catered perfectly for all the ravers and clubbers who wanted to continue the previous night fun through the day, who simply weren't yet ready to go home. I always thought it was an incredibly cool haven to attend on a Sunday afternoon and attended regularly. (*See* page 136)

———

With more and more parties and raves put on and with me spending more and more time in clubs and parties, my pockets, bum bag and backpack when I had one, would often be overflowing with flyers and invites for the latest parties and raves on offer. As such my collection, many of which are to be seen in the subsequent pages of this book, grew and grew.

And as the collection grew, so did the publicity surrounding the parties, their size, and quite rapidly the number of events being put on every weekend. So much so that by the end of the summer of 1989 (The Summer of Love which this book in part commemorates in its 25th anniversary year), the tabloids started reporting widespread panic across the nation due to the convoys of so-called crazed teenagers driving up and down motorways desperately following the radio message, pager instruction or follow-my-lead car to find the next great rave. The police took action, and while this was inevitable in Thatcher's Britain, it seemed somewhat heavy handed and totally off the mark to what was actually happening within the scene and by the people involved in it.

Whether 20,000 people actually did descend on to a Sunrise event or not isn't the point. Surely the police and other authorities should have accepted this widely growing youth, social – and in part economic – movement, and just be grateful that all the teenagers able to do so would be in one place at one time, mostly on happy drugs, not hurting anyone (or contrary to incorrect public belief, themselves) and let them get on with it?

Either way steps were being taken, Chief Super' Ken Tappenden set up the Police Pay Party Unit and info was supplied on promoters and organizers to be sought out and apprehended as if they were the heads of Mafia families. Regardless of the frenzy of concern by the (non-participating) public, the parties and raves went on unabated and bigger and louder and more well attended than ever, with the major promoters of Back to the Future, Sunrise and Biology handing out invites and flyers with premium phone numbers on for their regular ravers to get up to date information and buy tickets direct from them.

It had become and was continuing to be a huge commercial enterprise.

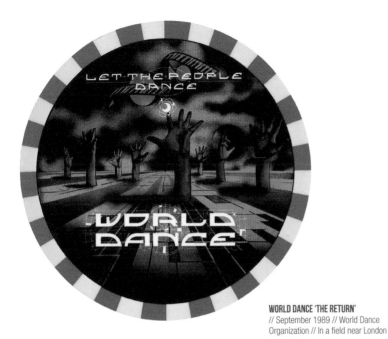

WORLD DANCE 'THE RETURN'
// September 1989 // World Dance
Organization // In a field near London

And so it was in early August that we followed thousands of cars and people to a field near the village of Longwick in Buckinghamshire (not far from where my father lived at the time), for a massive joint Sunrise and Back to the Future event: The 1989 Dance Music Festival. A reported 17,000 tickets sold for an event that lived up to the hype and included a great set from Carl Cox.

The following week one of the regulars on the scene from its earliest days, Anton Le Pirate and his World Dance Organisation, held their first event; World Dance in Godstone in Surrey. More than 8,000 people are reported to have partied through the night. It was a massive success despite the obligatory police presence, with a fantastic light and video wall and some great DJs, and as quoted from the flyer:

"MUSIC IS THE ONE TRULY INTERNATIONAL LANGUAGE, THUS SINCE TIME BEGAN MAN HAS CREATED AND DANCE(ED) FOR HIS PLEASURE: IT IS NOT A CRIME NOR AN OFFENCE… WE SAY 'LET THE PEOPLE DANCE'!"

(*See* page 126)

And they did, on a beautiful cloudless night with a partial full moon to add to the atmosphere that was felt by many to be a night of complete togetherness, that became one of the highlights of the summer. They also produced and distributed a really cool set of flyers that have been much in demand ever since, commanding some of the highest sale prices on auction sites like eBay to rave enthusiasts.

Energy's The Summer Festival on the August 26 went on to become one of *the* parties of "The Summer of Love". The promoters cleverly got around the police trying to infiltrate the ranks of party people by posing as ravers and monitoring the info lines to try to shut it down and the other events on at the same time, by sending out the message that the first 5,000 people to arrive at the event would get in free. Within a few hours there were three or four times that many, yes, 15-20,000 people dancing in a field in Effingham in Surrey to the sounds of Judge Jules, Paul Oakenfold, Fabio and all the way from New York, Frankie Bones. The police meanwhile were left unable to do anything but look on in wonder and awe. (*See* page 118)

In fairness, it had helped the Karma Productions team that both the Sunrise and Raindance events had been busted by the police earlier on in the evening with many ravers then joining the Energy rave, but still it was a huge event. With an enormous lighting rig on the stage, massive speaker stands either side of the main dance area, strobes and a huge canvas ball showing projected images, it was one of those events that has lived in many people's memories (despite the drizzle that come rolling in by the morning) and was one of the best of the year.

Previously that month, Genesis had readied themselves for 'The Empire Strikes Back' event on the 9th in a huge warehouse in East London that was supposedly big enough to hold 10,000 people, with fairground rides and a line up to rival any before, including Adamski and his "magic keyboard". (*See* page 106)

Exactly one month later, Biology planned the event Remembrance Dance, in memory of those lost to the disaster on the Thames when the *Marchioness* got hit in the early hours of August 20, 1989 and the pleasure boat sank after being run down by the dredger *Bowbelle* near the Cannon street railway bridge.

There were 131 people on the *Marchioness*, some members of the crew, some catering staff, whilst others were guests at a private birthday party. Fifty-one of them drowned, more than a handful were friends of the Biology Entertainment crew. The story goes that the Genesis publicity machine went ballistic, sending out numerous sets of flyers and a sticker campaign and had out stripped Biology's

sales, but disaster struck at 6am when the lighting crew were arrested by police, the fairground rides confiscated, and the promoters had to give up on the event. They generously redirected all of their ravers via the pirate radio stations to the Biology event held in Meopham in Kent. This was one night that we had all decided not to travel and spent the night in the West End instead. We eventually ended up back as we so often did in those days, at Tom Z's house in Hendon, to have our very own mini-rave with Frankie G on the decks, and very pleased about it we all were.

The following week Raindance held the first fully licensed all night dance event we'd heard of in Barking in Essex just outside London. Unsurprisingly it attracted a huge crowd. But it was the weekend of the 23rd that another Karma Productions event, was to give its profits to the Thames tragedy fund for those lost in the *Marchioness* disaster finally went ahead. Not at the original venue, which was discovered by police helicopter two hours before it was due to start, but illegally at Raydon Airfield in Suffolk. As planned, the now legendary Soul II Soul, Bomb the Bass Inner City and Smiley Culture were all booked and performed live on stage to outrageous applause. Whilst the rave was a brilliant success and much was raised for the disaster fund, it all ended badly the following morning with two cars on fire and promoter Jeremy Taylor arrested for causing a public nuisance. (*See* page 120)

Whilst we were all still having a great time at the raves and parties, and the overwhelming feeling was still one of unity and a shared energy, the police were doing their damnedest to block and stop every event they could, making for a less than enjoyable outing some weekends. One of those weekends was at the end of October when Biology planned to hold an event in Guildford with a massive line-up that was to include Public Enemy playing live…

You can imagine how fantastic this was going to be for us. One of our favourite acts live on stage and surely one of the raves of the year. Alas, due to the efforts of the press and the subsequent pressure put on MPs to end the "Acid peril of drugs kids", Tory MP Graham Bright pushed through the 'Entertainments (Increased Penalties) Act 1990' and the police increased the hunt for the event organizers and promoters and this event was one of the first to suffer.

With a massive police operation stopping the party, Public Enemy arrested and held at Heathrow airport and the entire area sealed off, us and tens of thousands of other party goers were left stranded and unable to get anywhere near the venue. For many of us it started going from bad to worse, and with the new legislation

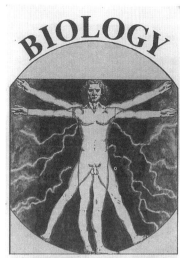

BIOLOGY
// September 1989
// Rememberance Dance, for those who lost their lives in the *Marchioness* tragedy

in place pirate radio stations were raided, their DJs arrested and promoters and organizers across the country were targeted, arrested, and the major raves raided or closed down. We were all still out there though, hanging in the clubs in the west end, still enjoying the regular trips down to Bristol and getting excited about the next big event or rave, but the writing was on the wall.

For New Year's Eve December 1989, Sunrise planned an end of the decade party, and for the first time decided to print the address of the venue on the flyer. It was a big mistake of course. With only hours to go before the event was to start, the pressure exerted on the landowner by the police to not allow use of the land was enough for the event to be called off. Sunrise's backup venue was miles away in Norfolk and even if they could get everyone there it had been given an injunction by the local council and that one was off too.

At around 11pm the message lines everyone relied upon to find out what's going on as noted on the flyers, directed the remaining ravers still hoping to spend New Year's Eve partying back across London to the now infamous M4, and Heston Services.

From there everyone was finally sent on to the National Panasonic Building in

Slough to join the Biology and Genesis party, but not us. We all headed back to Hendon and the safety of Tom's house and our own rave on safe and familiar ground and saw in the New Year with Frankie G playing the tunes.

1990 carried on much the same way 1989 had, with all the big promoters putting on events, but now it was in many cases in legal venues and away from the illegal ones in fields and on airstrips we went instead, as the government and police crackdown took hold in earnest. As the majority of the bigger London-based promoters and production companies had always got away with the parties, usually by advertising the events as "members' parties" with all tickets provided in advance, they were still in business and for a while simply moved into licensed and legal venues and carried on, but it wouldn't last. Soon the opportunity for the smaller promoter to get back on the scene opened up, new clubs and party nights sprang up and many ravers went back to being clubbers again. (*See* page 161)

The government and the police were, with their section 63, 64 and 65 legislation, trying to stop us having fun and continuing to party and rave, it wasn't going to happen without a fight, but it was the beginning of the end of the rave scene.

On January 27 I joined 8–10,000 people on a march from Islington to gather in Trafalgar square for the Freedom to Party Campaign, to hear speeches from the main protagonists and promoters of Sunrise, NRG and World Dance, including Anton Le Pirate, who spoke on behalf of the cause, while we listened to Debbie Malone sing 'Rescue Me'. Under the circumstances – not surprisingly – she had to do this a cappella, as the police wouldn't allow any music to be played over the sound system.

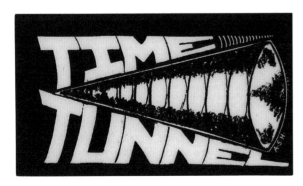

TIME TUNNEL
// December 1990–January 1991 // Shepherd's Bush Green, London W12

Later that evening an empty warehouse in Radlett in Hertfordshire (oddly where I went to school for a while) was found, and a party organized in just a few hours by the Weekend World crew. After the day's events I decided not to attend, which is just as well as the police road-blocked the convoys and ran pitched battles with the ravers trying to get into the building. As had been the case so often previously, somehow the rave did go on until the next morning.

I'd decided that despite having the best of times for the last few years, especially the last two on the rave scene at some of the biggest and best parties one could ever wish to attend, it was all getting a bit too much. The closed down or moved venues, hours on convoy on the road, the never knowing what you might find after a 4–6 hour journey took its toll, and my friends and I decided pretty much to a person to spend more of our time in the clubs we had grown to know and like so much rather than traipsing halfway across the south of England on a Saturday night and Sunday morning, hoping that the rave we were on our way to wouldn't be busted by the time we got there. The Freedom to Party Campaign did continue with a further rally on March 3, 1990 in Hyde Park, but by then, for us at any rate, the days and nights of chasing around the countryside were over. (*See* page 162)

It soon transpired that the police were most interested in closing down the illegal raves rather than stopping us partying. The clubs therefore found themselves able to offer slightly more relaxed licencing hours and longer opening times, which allowed us to be able to party all night in some venues as we wanted to, closer to home and back in the comfort of London's clubland. So it was to the likes of all-dayers at the Fridge in Brixton for Eureka and all-nighters at Hell we went.

To nights at the Town and Country Club in Kentish Town for Decadence, The Cat in the Hat at Legends on Old Burlington Street and to Hard Times in E8 we flocked.

Time Tunnel in Shepherd's Bush and our old favourite haunt, Solaris and its new sister and brother clubs Kimoto and Underwater in Grays Inn Road and Wardour Street respectively, were the places we now regularly frequented.

———

The music was still as fantastic as ever, the DJs just as good: Mark Moore, Paul Trouble Anderson, Evil Eddie Richards, Judge Jules, Fabio and Grooverider, Noel Watson, and Cleveland Anderson to name just a few, all still spinning the newest and best tunes and rocking the decks. The flyers and invites were still as clever and aesthetically pleasing and plentiful, the crowd just as eclectic as ever and in some cases even more

so. Actually with the scene now a year or two older and less frenetic, there was an even better vibe than there had been before the rave events took off.

Maybe people had learnt from the raves what community and unity was like, what a little give and take meant, how the mix of people, from all races, creeds and backgrounds was good for the scene (and us) and not detrimental, whilst relaxing the entry and door policy to include "all sorts" was a step forward for everyone.

Rave and house music had changed the way everything was working. It was going to influence, youth, club, music, art and culture forever, not just on the club scene and the business's associated with it but across the whole of society.

And the end of the farm-based, fairground ride, laser-toting raves, spawned the beginning of the mega-clubs and the increase in festivals. Fabric and Ministry of Sound in London for example, would not exist but for the rave scene. They filled the void and the demand left over when the big promoters like Energy could no longer fill the Docklands Arena or the Brixton Academy or the public wanted more comfort and better permanent sound systems, with no risk of the venues being closed down at the last minute. It gave us international DJs and record producers, international dance bands and artists, including Soul II Soul, Massive Attack, Faithless, KLF, Orbital, Prodigy, 808 State and S'Express, who, along with others transcended the genre and became the new popular music for the age.

You'll be hard pressed to find a chart track either here or in the US these days (and since the late-1980s/early 1990s) that is not dance or house music generated or inspired. We gave the Rave to the world and it has ended up with devotees either taking it with them when leaving these shores, or those who had come here and experienced it taking it back with them: to the US, to Ibiza and into Europe, Asia, Australia and beyond. Acid and House music came from The Warehouse in Chicago, dropped in on New York, landed in London, took root and flourished. It became the most influential youth culture phenomenon since punk. My collection of flyers provides me with a photo album look back into a period of my life that was exciting, inspirational, emotional, creative, educational and euphoric.

Looking over the collection provides a snapshot glimpse back to amazing shared moments in time. A time where we met people from all walks of life, without caring who they were, what they did, had or didn't have. Where we could forget the inequalities surrounding us, and for a short time enjoy not having to, or wanting to worry about tomorrow.

The words of Fingers Inc's, AKA Mr.Fingers, AKA Larry Heard, 'Can You Feel It' said it so well when the track was remixed to begin with the words of Martin Luther King Jr's famous "I have a dream" speech from 1963, calling for the end to racism, rather than the old spiritual leader lyrics of the early days.

As the huge beat came in to full effect he says: 'free at last, free at last, thank God Almighty, we are free at last'.

With Raves and Acid House music, at least right then, we really felt we were.

The Second Summer of Love left an indelible mark upon music, fashion, art, the people who took part, and went even beyond them into mainstream society.

Before too long, we did what we usually do with the creative influences garnered from the US and other places and Acid and House music especially: gave it back to them, bigger, better and with cherries on top!

Chelsea Louise Berlin, London 2014

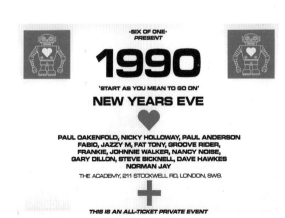

START AS YOU MEAN TO GO ON
// December 1990 // Six of One present 'New Year's Eve party' // The Academy, Stockwell Road, London SW9

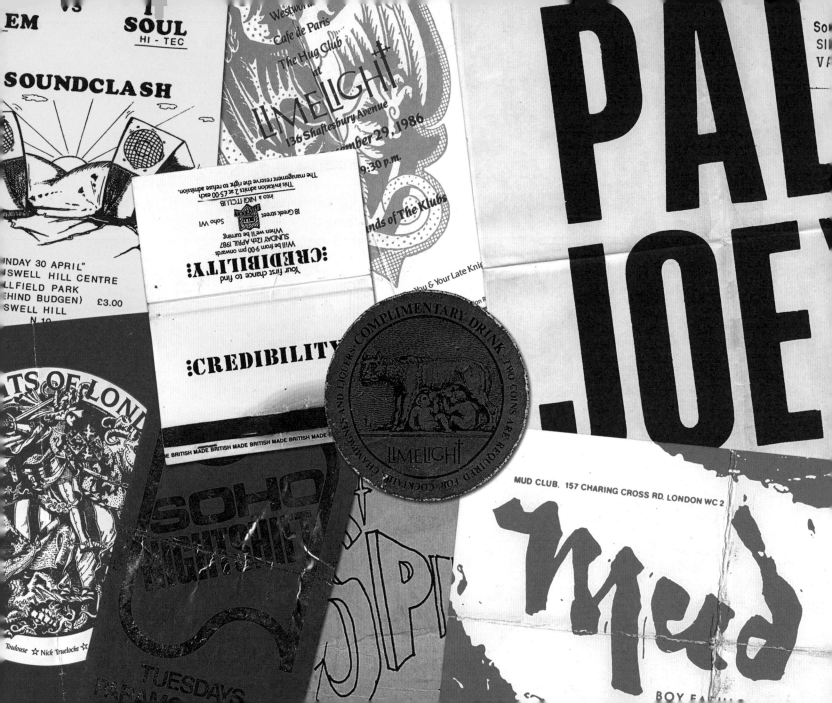

//1986/7

PISCES

IN THE BASEMENT
AT

LIMELIGHT

TUES 6th MARCH
10.30pm — 3am
With DJ's
Groove Rider
DJ Pillage
Cut Master J
& Guests

£5 Admission

Management reserves the right of admission.
136 Shaftesbury Avenue, London W1

*AN EXTREMELY
STYLISH EVENING*

In The Presence Of

His Majesty

THE KING OF FASHION:
Lord Barnsley Himself

Monday 25th May 1987

at

LIMELIGHT

136 Shaftesbury Avenue
Doors Open 9:30 p.m.
Be There Or Be Completely Unstylish!
DRESS: Ultimately Stylish
Tim Simenon & Nellee D.J.

Complimentary admission for you and your
Stylist with this invitation; £5 per person without.

This Invitation Cannot Be Sold Or Transferred
Right of Admission Reserved

Art 21

LIMELIGHT
// March 1986
// Pisces // Shaftesbury Avenue, London W1

LIMELIGHT
// May 1987
// 'An Extremely Stylish Evening' // Tim Simenon and Nellee // Shaftesbury Avenue, London W1

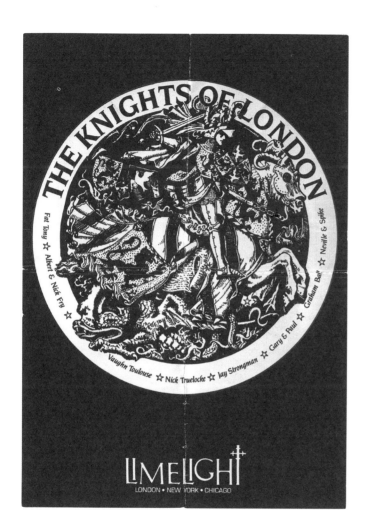

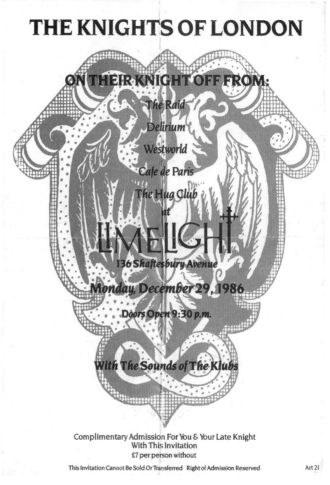

THE KNIGHTS OF LONDON

ON THEIR KNIGHT OFF FROM:

The Raid

Delirium

Westworld

Cafe de Paris

The Hug Club

at

LIMELIGHT

136 Shaftesbury Avenue

Monday, December 29, 1986

Doors Open 9:30 p.m.

With The Sounds of The Klubs

Complimentary Admission For You & Your Late Knight
With This Invitation
£7 per person without

This Invitation Cannot Be Sold Or Transferred Right of Admission Reserved Art 21

LIMELIGHT
// December 1986
// Knights of London // Shaftesbury Avenue, London W1

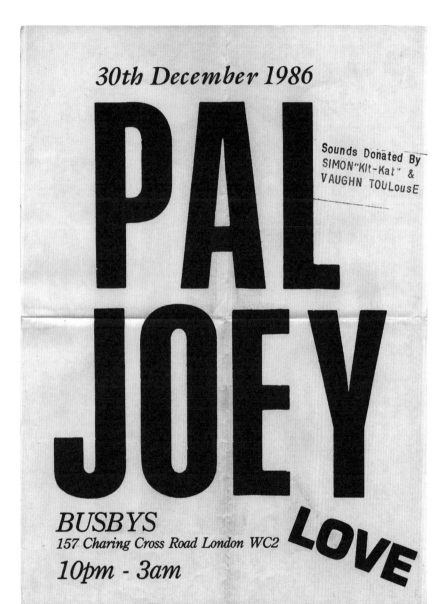

30th December 1986

PAL JOEY

Sounds Donated By
SIMON "Klt-Kat" &
VAUGHN TOULousE

BUSBYS
157 Charing Cross Road London WC2

10pm - 3am

LOVE

PAL JOEY
// December 1986
// Busbys // Charing Cross Road, London W1

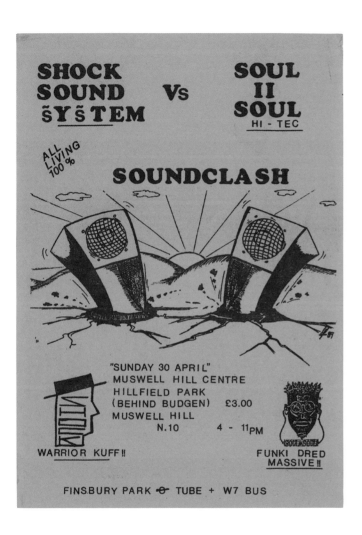

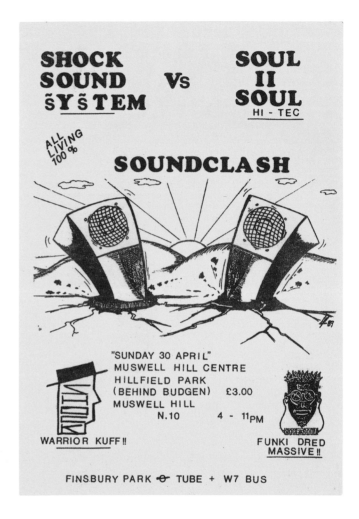

SOUNDCLASH
// 1986 (all year)
// Soul II Soul, Jazzie B and Norman Jay // Muswell Hill, London N10

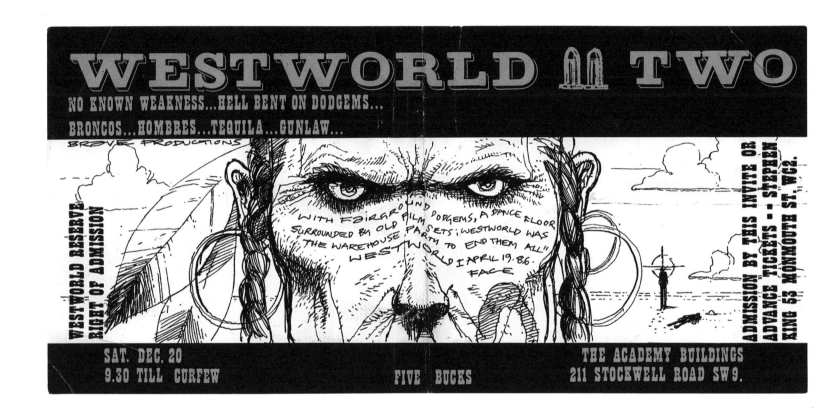

WESTWORLD TWO
// December 1986
// Academy buildings, Stockwell SW9

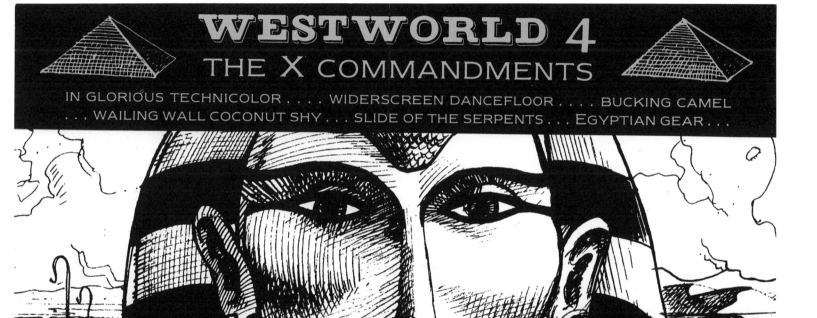

WESTWORLD 4
// April 1987
// The X Commandments // West London

INVITE ONLY

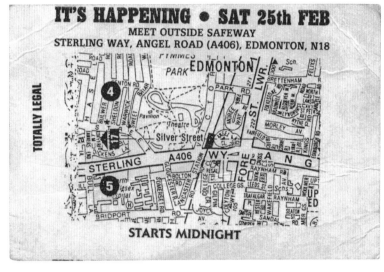

SPHERE
// February 1987
// Edmonton, London N8

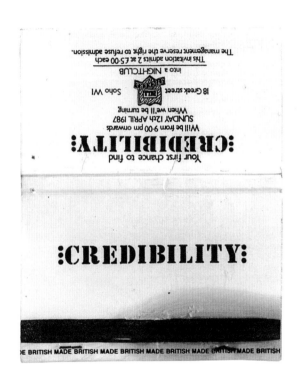

The management reserve the right to refuse admission.
This invitation admits 2 at £5·00 each

into a NIGHTCLUB

18 Greek street Soho W1

When we'll be turning.
SUNDAY 12th APRIL 1987
Will be from 9·00 pm onwards
:CREDIBILITY:
Your first chance to find

:CREDIBILITY:

CREDIBILITY
// April 1987 // Matchbook invite // Bill stickers
// Greek Street, London W1

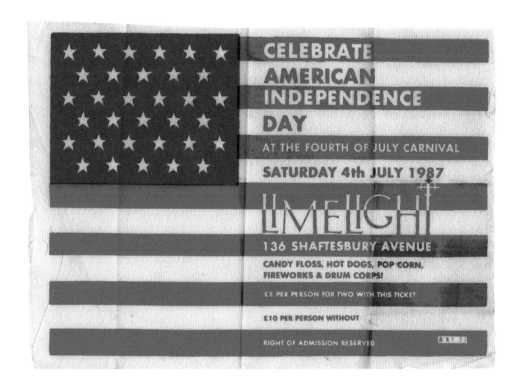

LIMELIGHT
// July 1987
// American Independence Day Carnival // Shaftesbury Avenue, London W1

LIMELIGHT
// Circa 1986/87 // Complimentary drinks ticket
// Shaftesbury Avenue, London W1

LIMELIGHT
// Circa 1986/87 // The Library // VIP room entry pass
// Shaftesbury Avenue, London W1

BROWNS MEMBERS CLUB
// Circa 1986/87 // VIP pass
// Shaftesbury Avenue, London W1

MUD CLUB. 157 CHARING CROSS RD. LONDON WC 2

mud

BOY FASHION SHOW — FRI OCT 16th 1987
BOY ROX THE WORLD
Summer '88 Collection

MUD CLUB
// October 1987 // Boy Fashion Show // Philip Salon promotes
// Charing Cross Road, London WC2

COMPLIMENTARY ADMISSION
EVERY TUESDAY
for wearer of this sticker

MANAGEMENT RESERVES THE RIGHT
OF ADMISSION & TO CHANGE
ENTRANCE CONDITIONS
WITHOUT NOTICE

SOHO
NIGHTSHIFT

TUESDAYS
PARAMOUNT CITY

SOHO NIGHTSHIFT
// Paramount City // Complimentary Tuesday pass (sticker)
// Off Shaftesbury Avenue, London W1

//1988

DISCOTEQUE
// February 1988 // Opening night // Nick Trulocke presents
// Old Astoria, Charing Cross Road, London WC2

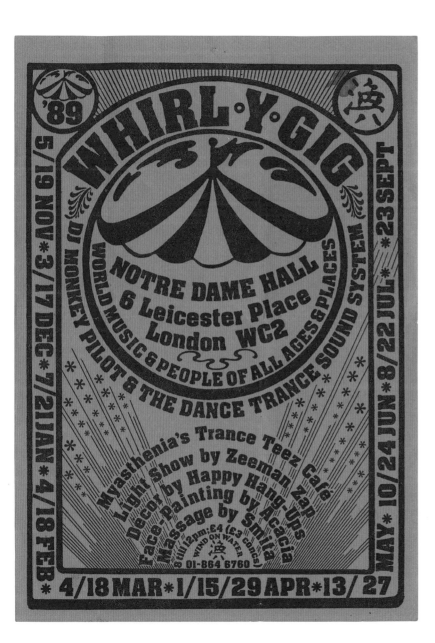

WHIRL-Y-GIG
// Circa 1988 ongoing // Monkey Pilot and friends
// Leicester Square, London WC2

Top fx
+ obscure
visuals by

JomaGeorge + Mindscape

Coozz
at the
Wag

Mr. C
Evil Ed
+ Colin Faver

Every Tuesday

from April 4th

Coozz
lightshow +
Marshmellow
Lounge

Live Percussions

Tickets sold by Black Market, 25 D'arblay St. W1. £5

Members £5
Non Members £6

10 tri 4

'OZONE
FRIENDLY'

COOZZ
// April 1988
// The Wag Club, Wardour Street, London W1

Now is the time of night
Dance on, to feel the sun
beyond all mortal dreams
where the venture is fresh and free
following darkness like a dream
So children of the night unite......

Begin your Summer Madness at the WAG with Coozz

RIP/FREQUENCY
// June 1988 // Paul Stone & Lu Vukovic
// Clink Street, London SE1

FREQUENCY
TWO THOUSAND VOLTA
PURE LIQUID CAPACITY

RIP: SATURDAY 17TH JUNE, 11PM TILL 7AM, NO ENTRANCE AFTER 2AM.
LOCATION: CLINK ST, ALL LEVELS. **ENQUIRIES:** CARLOS 739 1841. •
TICKETS ARE £8.00 AVAILABLE ON PRESENTATION OF MEMBERSHIP CARD
FROM: **BLACK MARKET,** 25 D'ARBLAY ST W1, SOHO, TEL: 01-437 0478 • **RED RECORDS,** 47 BEAK ST, NR
CARNABY ST, SOHO W1, TEL: 01-274 4476 • **RED RECORDS,** 500 BRIXTON RD, BRIXTON SW9, TEL: 01-734
2746 • **SOUL 11 SOUL,** THE BASEMENT, 162 CAMDEN HIGH ST NW1, TEL: 267 3995 • **VINYL ZONE,**
LONDON, 112 NEW KINGS RD W2, TEL: 384 2320 • **MUSIC POWER RECORDS,** 37 GRAND PARADE, GREEN
LANE N4, TEL: 800 6113.

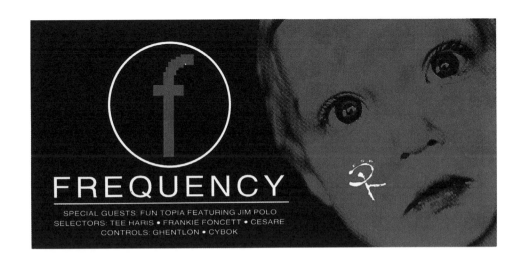

FREQUENCY

SPECIAL GUESTS: FUN TOPIA FEATURING JIM POLO
SELECTORS: TEE HARIS • FRANKIE FONCETT • CESARE
CONTROLS: GHENTLON • CYBOK

FREQUENCY
TWO THOUSAND VOLTA
NOISE GAS RATIO

RIP: SATURDAY 24TH JUNE, 11PM TILL 7AM, NO ENTRANCE AFTER 2AM.

ENQUIRIES: CARLOS 739 1841. • TICKETS AVAILABLE ON PRESENTATION

OF MEMBERSHIP CARD FROM: **BLACK MARKET,** 25 D'ARBLAY ST W1, SOHO, TEL: 01-437 0478 •
RED RECORDS, 47 BEAK ST, NR CARNABY ST, SOHO W1, TEL: 01-274 4476 • **RED RECORDS,** 500 BRIXTON
RD, BRIXTON SW9, TEL: 01-734 2746 • **SOUL 11 SOUL,** THE BASEMENT, 162 CAMDEN HIGH ST NW1, TEL:
267 3995 • **VINYL ZONE,** LONDON, 112 NEW KINGS RD W2, TEL: 384 2320 • **MUSIC POWER RECORDS,** 37
GRAND PARADE, GREEN LANE N4, TEL: 800 6113.

RIP/ FREQUENCY
//June 1988 // Paul Stone & Lu Vukovic
// Clink Street, London SE1

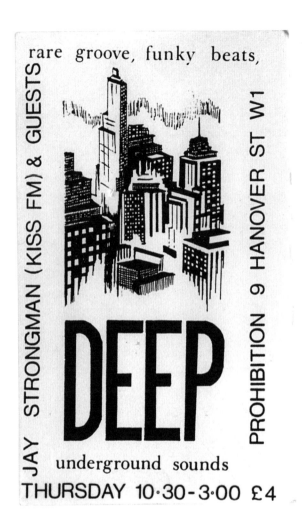

rare groove, funky beats,

JAY STRONGMAN (KISS FM) & GUESTS

PROHIBITION 9 HANOVER ST W1

DEEP
underground sounds

THURSDAY 10·30-3·00 £4

DEEP
// Circa 1988 // Jay Strongman presents
// Prohibition, Hanover Street, London W1

FREEDOM
// Circa 1988 // Steve Swindels presents FAQ
// Wardour Street, London W1

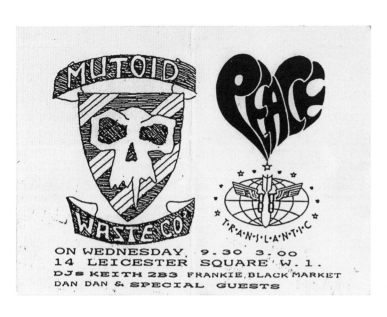

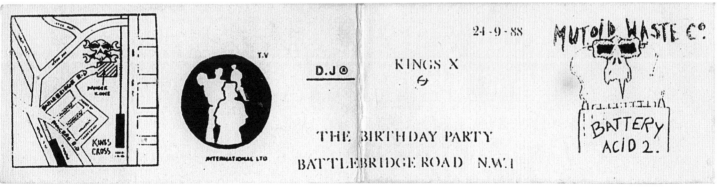

MUTOID WASTE CO
// August 1988 // 'Translantic'
// Leicester Square, London W1

MUTOID WASTE CO
// September 1988 // 'The Birthday Party'
// Battle Bridge Road, London NW1

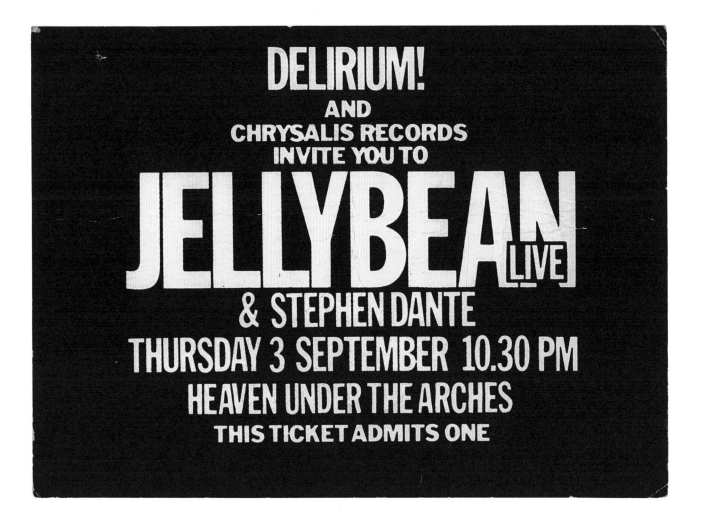

DELIRIUM!
// September 1988 // Delirium! and Chrysalis Records present
// Heaven, Villiers Street, London WC2

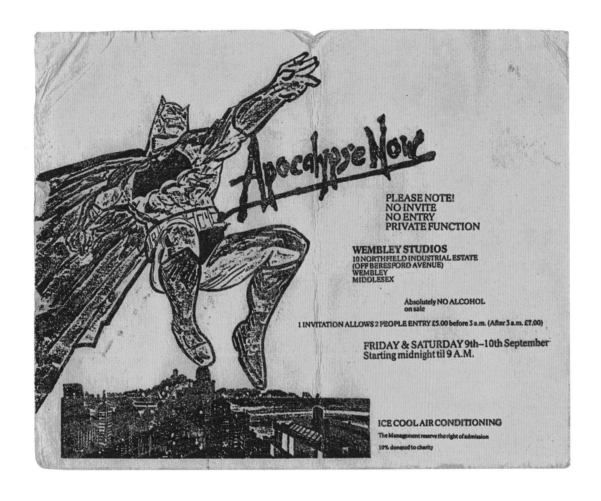

APOCALYPSE NOW
// September 1988 // Tony Colston-Hayter presents
// Wembley Studios, Wembley, Middlesex

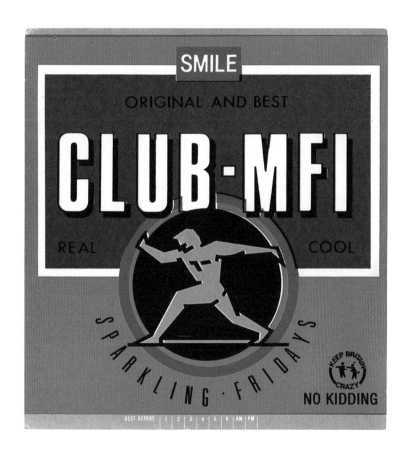

SMILE

ORIGINAL AND BEST

CLUB·MFI

REAL COOL

SPARKLING · FRIDAYS

KEEP BRITAIN CRAZY

NO KIDDING

BEST BEFORE | 1 | 2 | 3 | 4 | 5 | 6 | AM | PM

TEL: 01-437 9933

APPROVED INGREDIENTS: WATER (SWEAT).
CARBONATED AIR. COLOUR (ALL WELCOME)
FLAVOURINGS. PRESERVATIVE.
ENERGY LEVEL HIGH

SPARKLING FRIDAYS AT
LEGENDS OLD BURLINGTON STREET
A NEVILLE & SPIKE PRODUCTION

**WARNING: THIS PRODUCT CAN CAUSE LUNG BURN OUT
DO NOT USE IF YOU ARE NOT COMPLETELY MAD FOR IT**

CLUB MFI
// 1988 onwards // A Neville and Spike production
// Legends, Old Burlington Street, London W1

AN INVITATION TO THE OPENING

DELIRIUM!

SATURDAY SEPTEMBER 13th

Def Jam

GUESTS
LIVE ON STAGE 2am
DJs NOEL & MORRIS WATSON – THE NYC MASTERS
PLUS THE BOILERHOUSE RACHAEL AUBURN DAVE DORRELL
BMX. DANCE. ART. FILMS

147 CHARING X RD. ADMISSION FIVE POUNDS BEFORE 3am THREE POUNDS AFTER
11pm THRU' TILL 8am

MASTERMIX NICK TRULOCKE AND ROBIN KING

DELIRIUM!
// September 1988 // Opening night // Nick Trulocke and Robin King present
// Charing Cross Road, London WC2

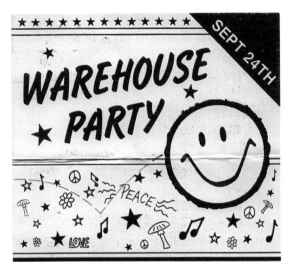

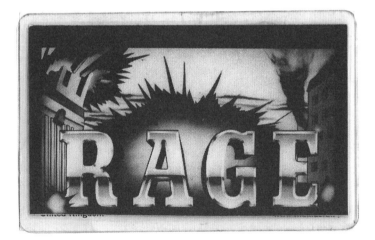

WAREHOUSE PARTY
// September 1988 // H&P Enterprises
// Caledonian Road, London N7

RAGE
// Circa 1988
// VIP card

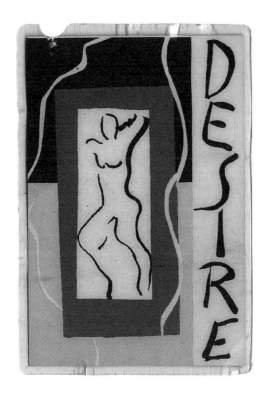

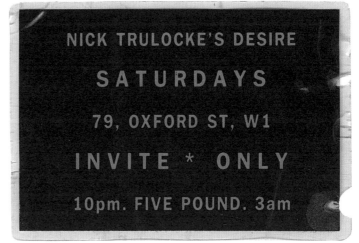

NICK TRULOCKE'S DESIRE

SATURDAYS

79, OXFORD ST, W1

INVITE * ONLY

10pm. FIVE POUND. 3am

DESIRE
// Circa 1988 // Nick Trulocke presents
// Oxford Street, London W1

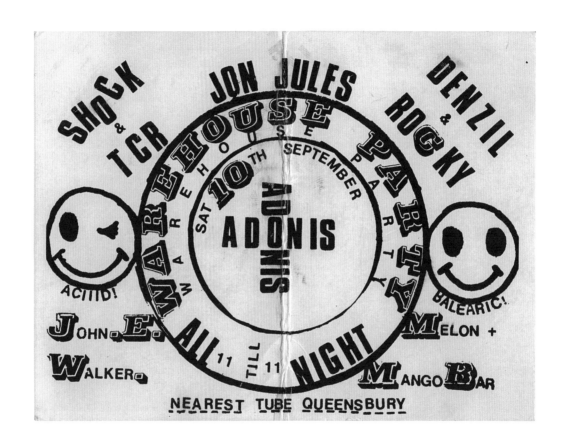

ADONIS
// September 1988 // Mix DJ promoters // Rocky & Denzil/TCR & Shock/Jon Jules
// Queensway, London W2

SOUL PIT
// October 1988
// Harlesden, London NW10

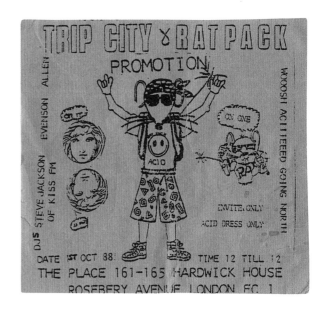

WHOOSH ACID
// October 1988 // Rat Pack and Trip City promotions
// Hardwick House, London EC1

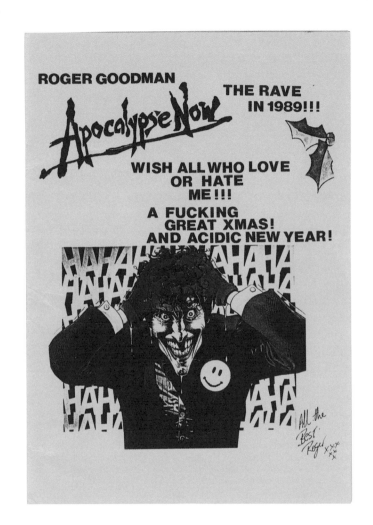

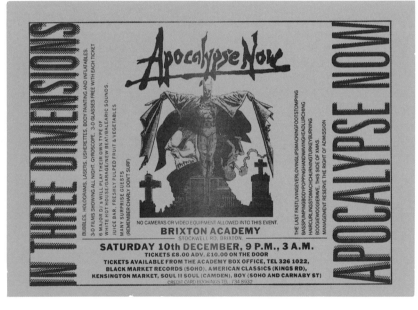

APOCALYPSE NOW
// December 1988
// Roger Goodman Xmas card

APOCALYPSE NOW
December 1988 // 'In Three Dimensions' // Tony Colston-Hayter
presents // Brixton Academy, London SW9

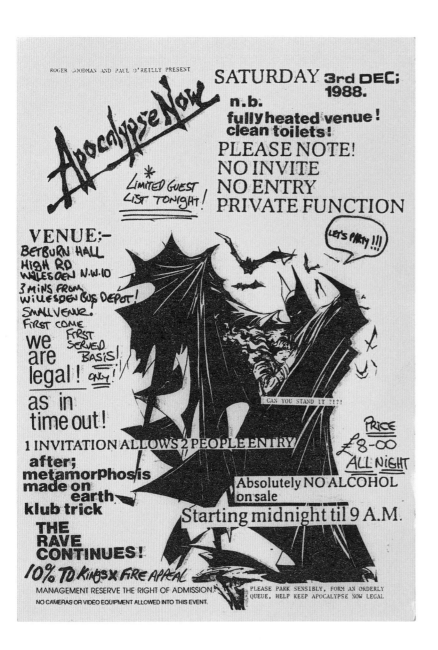

APOCALYPSE NOW

// December 1988 // 'In Three Dimensions' // Roger Goodman and Paul O'Reilly present
// Betburn Hall, Willesden, London NW10

OPERA·HOUSE

1989

	JANUARY	FEBRUARY	MARCH
S	1 8 15 22 29	– 5 12 19 26	– 5 12 19 26
M	2 9 16 23 30	– 6 13 20 27	– 6 13 20 27
Tu	3 10 17 24 31	– 7 14 21 28	– 7 14 21 28
W	4 11 18 25	1 8 15 22 29	1 8 15 22 29
Th	5 12 19 26	2 9 16 23	2 9 16 23 30
F	6 13 20 27	3 10 17 24	3 10 17 24 31
S	7 14 21 28	4 11 18 25	4 11 18 25

	APRIL	MAY	JUNE
S	2 9 16 23 30	– 7 14 21 28	– 4 11 18 25
M	3 10 17 24	1 8 15 22 29	– 5 12 19 26
Tu	4 11 18 25	2 9 16 23 30	– 6 13 20 27
W	5 12 19 26	3 10 17 24 31	– 7 14 21 28
Th	6 13 20 27	4 11 18 25	1 8 15 22 29
F	7 14 21 28	5 12 19 26	2 9 16 23 30
S	1 8 15 22 29	6 13 20 27	3 10 17 24

	JULY	AUGUST	SEPTEMBER
S	2 9 16 23 30	6 13 20 27	– 3 10 17 24
M	3 10 17 24 31	7 14 21 28	– 4 11 18 25
Tu	4 11 18 25	1 8 15 22 29	– 5 12 19 26
W	5 12 19 26	2 9 16 23 30	– 6 13 20 27
Th	6 13 20 27	3 10 17 24 31	– 7 14 21 28
F	7 14 21 28	4 11 18 25	1 8 15 22 29
S	1 8 15 22 29	5 12 19 26	2 9 16 23 30

	OCTOBER	NOVEMBER	DECEMBER
S	1 8 15 22 29	– 5 12 19 26	3 10 17 24 31
M	2 9 16 23 30	– 6 13 20 27	4 11 18 25
Tu	3 10 17 24 31	– 7 14 21 28	5 12 19 26
W	4 11 18 25	1 8 15 22 29	6 13 20 27
Th	5 12 19 26	2 9 16 23 30	7 14 21 28
F	6 13 20 27	3 10 17 24	1 8 15 22 29
S	7 14 21 28	4 11 18 25	2 9 16 23 30

Philip Sallon
invites you to
THE OPERA HOUSE
and
MUD CLUB
XMAS BALL
WEDNESDAY 21st DECEMBER 1988

EMPIRE BALLROOM, Leicester Square, WC2

OPERA HOUSE
// December 1988 // Opera House and Mud Club Xmas Ball // Philip Salon presents
// Empire Ballroom, London WC2

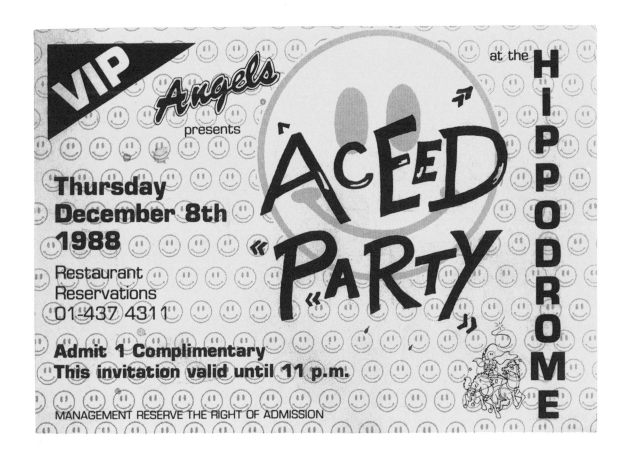

HIPPODROME
// December 1988 // Angels presents 'Aceed Party'
// Leicester Square, London W1

WHITE LINE FEVER
// Circa October 1988 // Crash System presents
// Priory Studios, London NW6

CRASH SYSTEM
presents
**WHITE LINE
FEVER**
A
Multi media
Happening with
25 Screens of
Wet Dreams

Location

Priory Studios
252 Belsize Rd
NW6
Sat. 30 June
11.00 - Late

Audio

Uzi Al and IT
Christian
Jeremy Healey
DJ Mouse
Bill Nasty

Visual

Dream Team
Jamie Rose
James LeBon
Medium Massage
Phil B

Advance Invites
Black Market 071 437 0478
Bond 071 437 0079
Zoom 071 267 4479
Utopia 071 352 0333

THE END

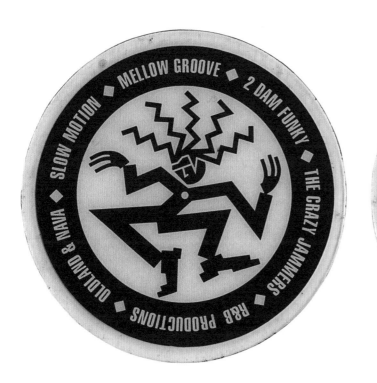

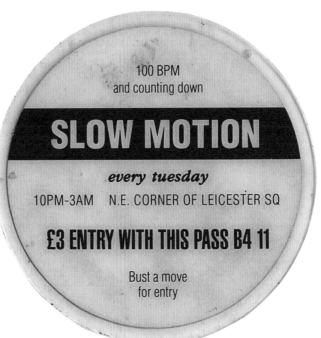

DISCOTEQUE

// Slow Motion // Circa 1988 // R&B Productions
// Leicester Square, London WC2

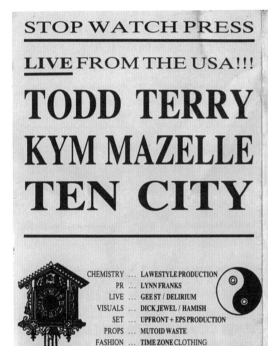

STOP WATCH PRESS

<u>LIVE</u> FROM THE USA!!!

TODD TERRY
KYM MAZELLE
TEN CITY

CHEMISTRY ...	LAWESTYLE PRODUCTION
PR ...	LYNN FRANKS
LIVE ...	GEE ST / DELIRIUM
VISUALS ...	DICK JEWEL / HAMISH
SET ...	UPFRONT + EPS PRODUCTION
PROPS ...	MUTOID WASTE
FASHION ...	TIME ZONE CLOTHING
SOUNDS ...	25k TURBO + MANASSAH + SOUL II SOUL
FILMS ...	BIG TV ... VIEWS FROM REEL WORLD

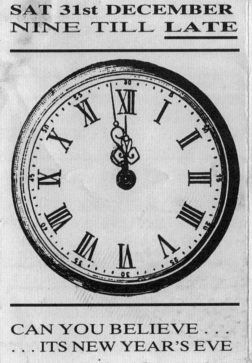

SAT 31st DECEMBER
NINE TILL <u>LATE</u>

CAN YOU BELIEVE . . .
. . . ITS NEW YEAR'S EVE

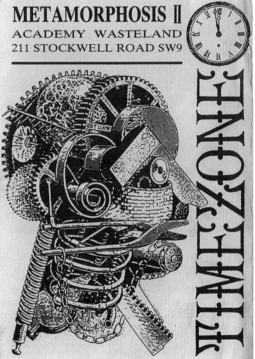

METAMORPHOSIS II
ACADEMY WASTELAND
211 STOCKWELL ROAD SW9

TIMEZONE

METAMORPHOSIS II
// December 1988 // 'Timezone' // Lawstyle Productions
// Academy Wasteland, London SW9

3 DANCE ZONES + MORE
TODD TERRY . . . **NYC**
DERREK BOLLAND . . . BLACK MARKET
PAUL OKENFOLD . . . SPECTRUM

NOEL WATSON . . . **DELIRIUM!**
TREVOR FUNG . . . ENTER THE DRAGON
MARC MOORE . . . MUD CLUB

JAZZY B . . . **SOUL II SOUL**
MANASSAH . . . **SPIN**
GAZ . . . **ROCKIN' BLUES**

PARTY ON TIMEZONE WITH
MUTOID WASTE CLOCKS

MUSIC TIMEZONE WITH
TODD TERRY FROM NYC
BANDS . . . PAs . . . + MORE

A FUTURE TIMEZONE
WITH FORTUNE TELLING
+ 1990's FASHION SHOW

GO GO DANCERS . . . ROLLERSKATES
MARTIAL ARTS . . . FILM . . . VIDEO
AND **FREE** DRINKS AT MIDNIGHT

TIMEZONE CHANGES ON
NEW YEARS EVE 1988
AT ACADEMY WASTELAND

TICKETS ARE £15 FROM
ACADEMY WASTELAND 01-326 1022
BOY . . . BLACK MARKET . . . STEPHEN KING
REVAMP . . . SOUL II SOUL AND OTHERS

THIS INVITATION EXTENDS TO
FRIENDS . . . LOWLIFES . . . CELEBRITIES
PUNKS . . . DREADS . . . AND OTHER IDEALISTS
TO SPEND NEW YEARS EVE
TOGETHER FOR A CHANGE

//59

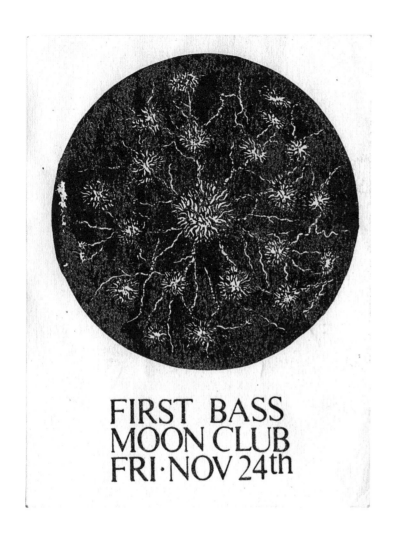

FIRST BASS
MOON CLUB
FRI·NOV 24th

FIRST BASS
// November 1988
// The Moon Club, Bristol

THE PRIME TIME CREW
// Circa 1988 onwards
// Membership card

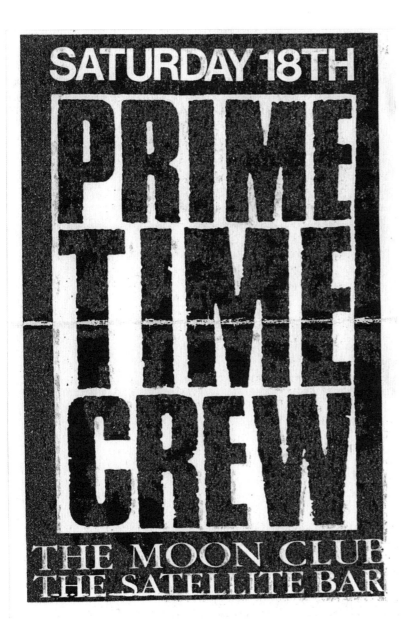

SATURDAY 18TH
PRIME TIME CREW
THE MOON CLUB
THE SATELLITE BAR

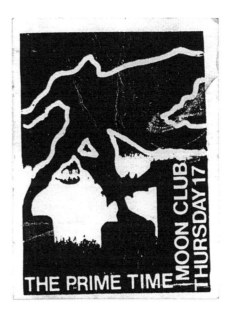

THE PRIME TIME | MOON CLUB THURSDAY 17

THE SATELLITE BAR
// October 1988
// The Moon Club, Bristol

THE MOON CLUB
// December 1988
// Bristol

DEFCON
// Circa 1988
// Membership card

SOMETHING FOR THE WEEKEND
// April 1988
// Mayfair Suite, Bristol

"SOMETHING FOR
THE WEEKEND"
DEF CON > iD & Dr Jam
Mayfair Suite
Saturday 28th April
Serious P.A & Lights
£5 or £4 with Def Con Plasti-

GET DIGITAL 2
// November 1988
// Thekla, Bristol

UNDERWATER

OPENING NIGHT 18th OCTOBER
EVERY WEDNESDAY 10pm-3.30am
AT 201 WARDOUR ST., LONDON W.1.
SPECIALIZING IN THE EVOLUTION OF EUROPEAN & AMERICAN HOUSE MUSIC
£7 ADMISSION WITH THIS INVITATION

RIGHTS OF ADMISSION ARE RESERVED BY THE MANAGEMENT.

VIR

BACK
FUT

MORE BOUNCE TO THE OUNCE

HYPNOSIS

TRIBAL DANCE PRESENTS

SOL

COMES
ON FRIDAY 1ST S
AT THE SA
THE OLD ST
TICKETS £8 INCLUDE
£5 ADMISSIO
MUSIC: ROSO
CHOO

ENIGMATIC PRO

TIL ETERNITY

BIOLOGY

MEMBERSHIP CARD

goban

urday Octo

GENESIS 89

KARM

E

P
A
R

Tribes Back

//1989

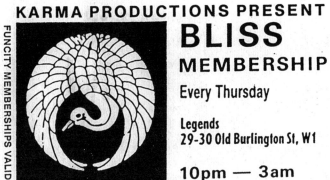

BLISS
// Circa 1989 // Membership card // Karma Productions
// Legends, Old Burlington Street, London W1

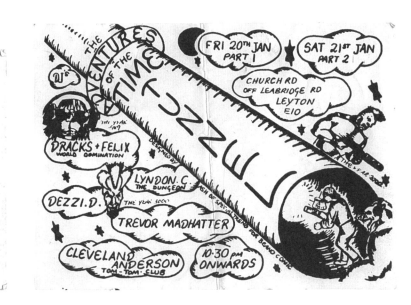

TIME TUNNEL
// January 1989
// Leabridge Road, Leyton, London E10

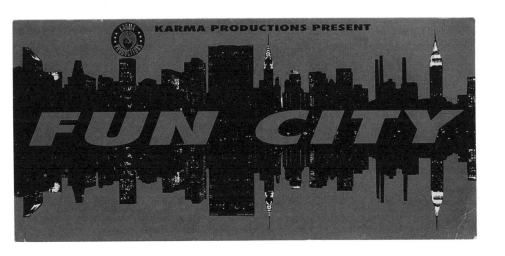

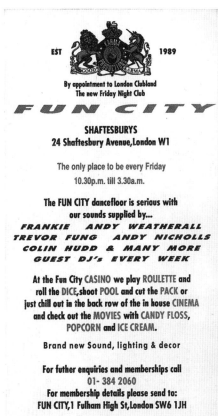

FUN CITY
// Circa 1989 // Karma Productions
// Shaftesbury Avenue, London W1

NEVILLE SPIKE & TBT
INVITE YOU TO
THE ST. VALENTINES DAY
MASSACRE
AT LEGENDS
OLD BURLINGTON ST W1
14 FEB 1989
For further information
Tel. 734 6620
or call at
68 Berwick St.
W1

ST. VALENTINE'S DAY MASSACRE
// February 1989 // Neville, Spike and TBT present
// Legends, Old Burlington Street, London W1

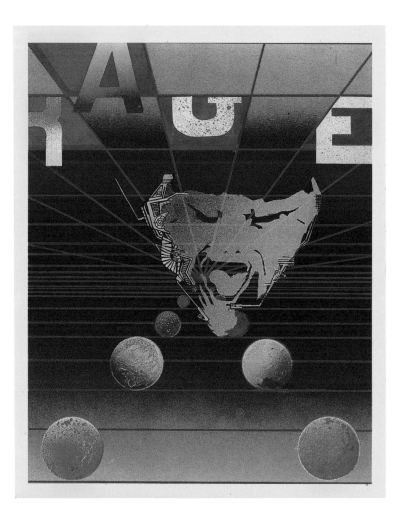

RAGE

At Heaven Under the Arches WC2 on
Thursday 8th Feb

DJs: Colin Faver·Trevor Fung
Groove Rider·Fabio·Craig·Grant

3 Dance Floors • 21k Turbo Sound
Spectacular Lazers • Juice Bar

ATTENTION!

RAGE is now a members only club.
NO MEMBERSHIP NO ADMISSION
MEMBERSHIPS ARE STILL AVAILABLE

For details of membership call 839 5458
2nd floor, 34 Craven St. WC2 (Next to Heaven)
Monday-Saturday 10.30–7.30 Admission £8

RAGE
// February 1989 // Fabio and Grooverider present
// Heaven, Villiers Street, London WC2

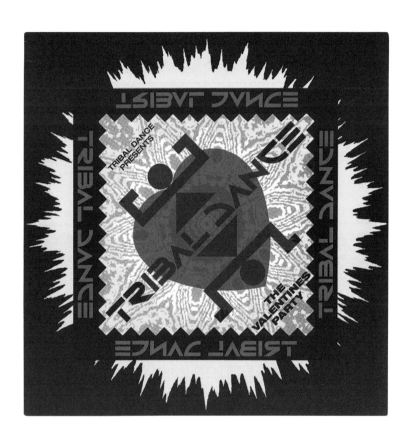

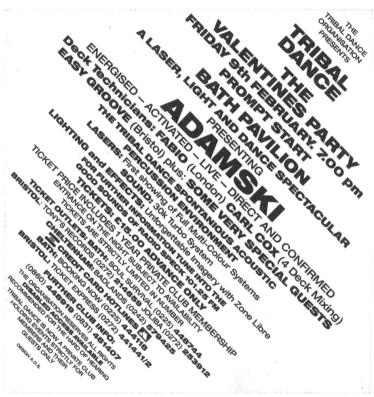

TRIBAL DANCE
// February 1989 // The Valentine's Party // Tribal Dance Organization
presents // Bath Pavilion, Bath

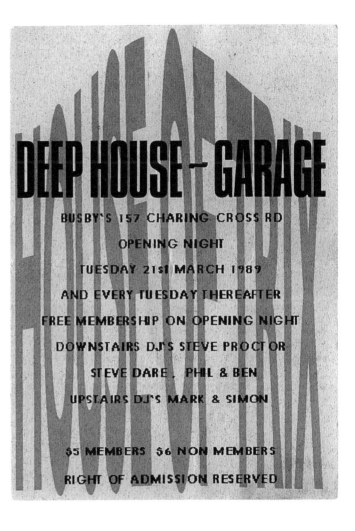

DEEP HOUSE – GARAGE

BUSBY'S 157 CHARING CROSS RD

OPENING NIGHT

TUESDAY 21st MARCH 1989

AND EVERY TUESDAY THEREAFTER

FREE MEMBERSHIP ON OPENING NIGHT

DOWNSTAIRS DJ'S STEVE PROCTOR

STEVE DARE , PHIL & BEN

UPSTAIRS DJ'S MARK & SIMON

$5 MEMBERS $6 NON MEMBERS

RIGHT OF ADMISSION RESERVED

HOUSE OF TRIX
// March 1989 // Opening night party
// Steve Proctor, Steve Dare, Phil & Ben – Busbys, Charing Cross Road, London WC2

SUPERSTITION

EVERY FORTNIGHT COMMENCING
SATURDAY 18 MARCH

D. J. DAVE DORRELL
+ GUESTS

2 DANCE FLOORS
CHEAP BAR

10PM TO 4AM

JUICE BAR
FROM 2AM

ADMISSION £5 WITH INVITE
£6 WITHOUT

THORNHAUGH ST.
OFF RUSSELL SQ.
WC1

FORTUNE TELLER
LIVE MUSIC

SUPERSTITION
// March 1989 // Dave Dorrell presents
// Thornhaugh Street, London WC1

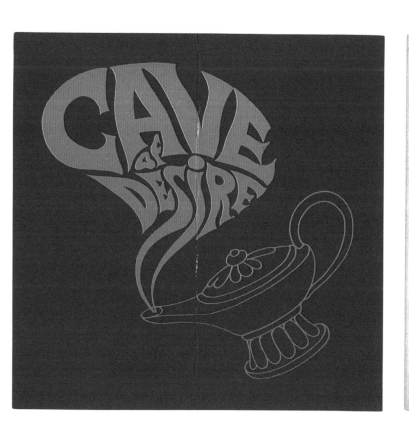

An all day technicolour magic circus.

ALL DAYER 4pm – 1am

SUNDAY 5th MARCH 1989
Ticket £10 in advance FROM HEAVEN
or 40 CRAVEN STREET LONDON WC2
£12 on door

at HEAVEN, THE ARCHES, CRAVEN STREET, WC2

D.J.'s –

COLIN FAVER – LOWER CAVERN
CESARE – LOWER CAVERN
CASBAH D.J.'s – UPPER CAVERN
JAY GEE – UPPER CAVERN
D.J. GLOBAL – UPPER CAVERN
EVIL EDDIE – LOWER CAVERN
D.J. NO NAME – UPPER CAVERN

LIVE DANCE MUSIC –
ORCHESTRA JAZIRA
SAMBA DRUMMING
JACK THE TAB
PSYCHIC TV
SKULPTURE
LONDON SCHOOL OF
SAMBA,
PLUS SURPRISES...

Other Goodies –

EXOTIC FOODS BAZAARS
LIGHTSHOWS HENNA PAINTING
BODY PAINTING JUGGLERS
BELLY DANCERS MYSTICS
FIRE EATERS TAROT

CAVE OF DESIRE
// March 1989 // The Pure Organization presents
// Heaven, Villiers Street, London WC2

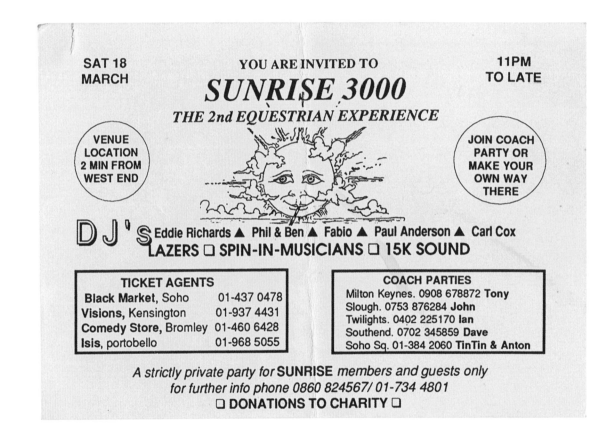

SAT 18 MARCH

YOU ARE INVITED TO

SUNRISE 3000

THE 2nd EQUESTRIAN EXPERIENCE

11PM TO LATE

VENUE LOCATION 2 MIN FROM WEST END

JOIN COACH PARTY OR MAKE YOUR OWN WAY THERE

DJ'S Eddie Richards ▲ Phil & Ben ▲ Fabio ▲ Paul Anderson ▲ Carl Cox
LAZERS ❑ **SPIN-IN-MUSICIANS** ❑ **15K SOUND**

TICKET AGENTS	
Black Market, Soho	01-437 0478
Visions, Kensington	01-937 4431
Comedy Store, Bromley	01-460 6428
Isis, portobello	01-968 5055

COACH PARTIES
Milton Keynes. 0908 678872 **Tony**
Slough. 0753 876284 **John**
Twilights. 0402 225170 **Ian**
Southend. 0702 345859 **Dave**
Soho Sq. 01-384 2060 **TinTin & Anton**

A strictly private party for **SUNRISE** *members and guests only*
for further info phone 0860 824567/ 01-734 4801
❑ **DONATIONS TO CHARITY** ❑

SUNRISE 3000
// March 1989 // The 2nd Equestrian Event
// Central London

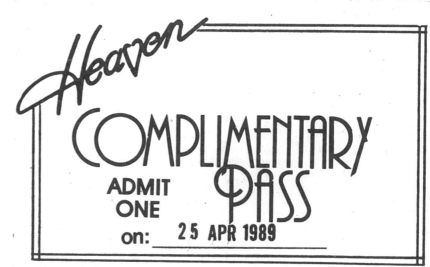

SOLARIS
// Circa 1988 // Membership card // Nick Coleman presents
// Grays Inn Road, London WC1

HEAVEN
// April 1989 // Complimentary pass
// Villiers Street, London WC2

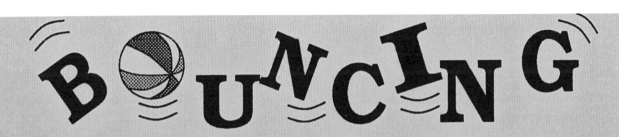

DJ 'S FROM THE DUNGEON
MR C
LINDEN C
ROB ACTESON
EVIL EDDIE RICHARDS

SAT 22 ND APRIL 1989

BRENT CROSS
11-- 9 AM
FREE COACH
INFORMATION
RING: 505 3657
(24hr hot line)

BOUNCING
CONCEPT & PRINT BY DTP 01 519 3814

BOUNCING
// April 1989
// Pick-up, London NW11

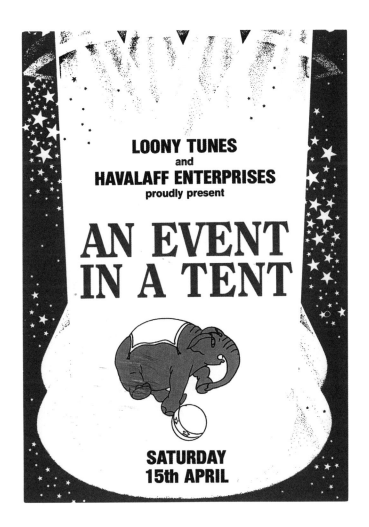

LOONY TUNES
and
HAVALAFF ENTERPRISES
proudly present

AN EVENT IN A TENT

**SATURDAY
15th APRIL**

FOR YOUR EDIFICATION AND ENJOYMENT...

GASP IN WONDER
at our death-defying DJs!
- Tony 'Tightrope Walker' Wilson
- Fat Tony and his Amazing Python
- Fabio 'The Human Cannonball'
- The Conjuring Carl Cox
- The Vanishing Vicki Edwards
- Groove 'Bareback' Rider
- Von the Lion Tamer
- The Juggling Matt Black
- DJ Louise on Trapeze

THRILL to the sight of our lazer lightshow, staggering special F/X, amazing sound systems, sumptuous drapes, chandeliers and dazzling dance floor!

FUN! FUN! FUN! FOR ALL THE FAMILY
* Sweets, balloons and take-home prezzies.
* Donations to charity
Venue: **SYON LANE** (off the Great West Road) **ISLEWORTH**

Phone
01-378 0605
for Coach Booking and Information
Private Party. Admission by Invitation Only

AN EVENT IN A TENT
// April 1989 // Loony Tunes and Havalaff Enterprises
// Syon Lane, Isleworth, Middlesex

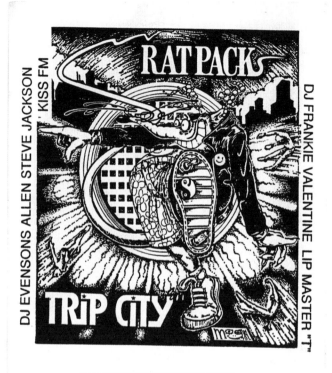

TRIP CITY
// April 1989 // Rat Pack presents
// Elephant and Castle, London SE17

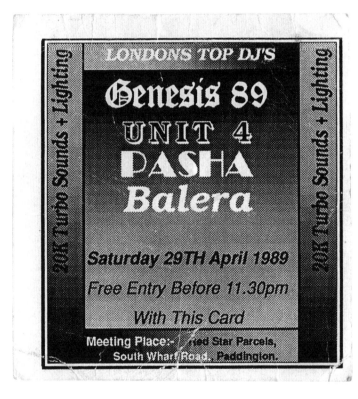

MULTI EVENT
// April 1989 // Genesis/Pasha and Unit 4 presents
// Meeting in Paddington, London W2

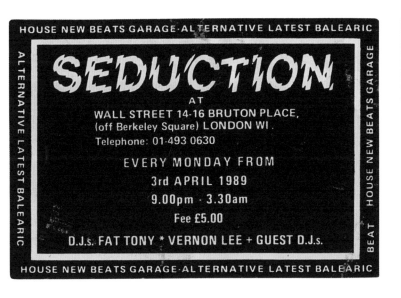

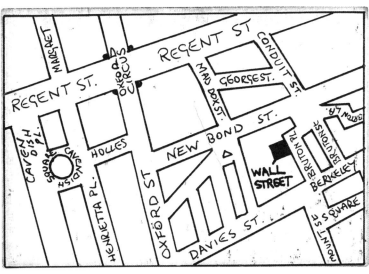

SEDUCTION
// April 1989 // Fat Tony presents
// Wall Street, Bruton Place, London W1

BIOLOGY

PRIVATE HOUSE PARTY

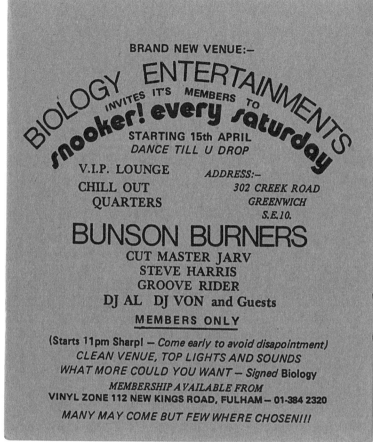

BRAND NEW VENUE:–

BIOLOGY ENTERTAINMENTS

INVITES IT'S MEMBERS TO

snooker! every saturday

STARTING 15th APRIL
DANCE TILL U DROP

V.I.P. LOUNGE

CHILL OUT
QUARTERS

ADDRESS:–

302 CREEK ROAD
GREENWICH
S.E.10.

BUNSON BURNERS

CUT MASTER JARV
STEVE HARRIS
GROOVE RIDER
DJ AL DJ VON and Guests

<u>MEMBERS ONLY</u>

(Starts 11pm Sharp! — *Come early to avoid disapointment*)
CLEAN VENUE, TOP LIGHTS AND SOUNDS
WHAT MORE COULD YOU WANT — Signed Biology
MEMBERSHIP AVAILABLE FROM
VINYL ZONE 112 NEW KINGS ROAD, FULHAM — 01-384 2320

MANY MAY COME BUT FEW WHERE CHOSEN!!!

BIOLOGY
// April 1989 // Snooker!
// Creek Road, Greenwich

BIOLOGY

PRIVATE HOUSE PARTY

302 Creek Road, Greenwich S.E.10

EVERY SATURDAY

THIS SATURDAY

SAFE RAVE

EVERY SATURDAY

11pm till Late

BIOLOGY
// Circa 1989 // Safe Rave
// Creek Road, Greenwich

METAMORPHOSIS V

SPECIAL
SOUL II SOUL
ASWAD
KYM MAZELLE
ADEVA
DENNIS BROWN
JUNGLE BROS
WITH RICHIE RICH

PLUS A MYSTERYMORPHOSIS SURPRISE GUEST

THURSDAY 20 APRIL 9.00 – 3.00AM
BRIXTON ACADEMY

➤ TICKETS £10 ADV FROM ➤ ACADEMY BOX OFFICE [326 1022] ➤ SOUL II SOUL
➤ BLACK MARKET ➤ BOY [SOHO] ➤ STEPHEN KING ➤ THE DISPENSARY
[NOTTING HILL GATE] ➤ RED RECORDS [SOHO] ➤ REVAMP [CHELSEA] ◄

SUNRISE &
BACK TO THE FUTURE
Joint Club Membership

YOU WILL RECIEVE INVITATIONS TO ALL OUR EVENTS
TICKETS ARE ONLY AVAILABLE ON
PRESENTATION OF THIS MEMBERSHIP CARD

№ 7299

METAMORPHOSIS V
// April 1988 onwards
// Brixton Academy, London SW9

SUNRISE & BACK TO THE FUTURE
// Joint club membership card

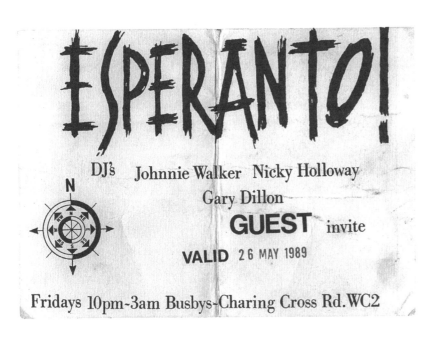

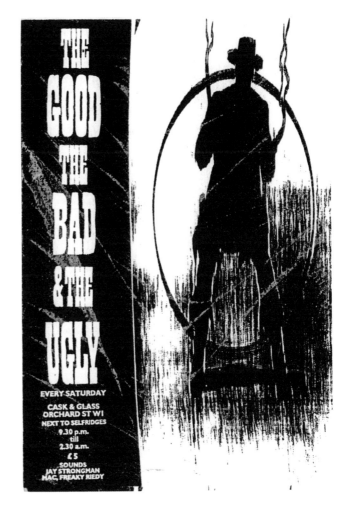

ESPERANTO
// May 1989 // Guest invite
// Busbys, Charing Cross Road, London WC2

THE GOOD, THE BAD & THE UGLY
// Circa 1989
// Cask and Glass, Orchard Street, London W1

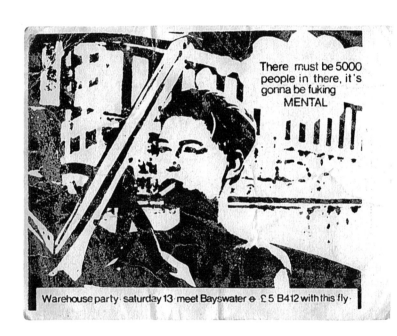

There must be 5000 people in there, it's gonna be fuking MENTAL

Warehouse party · saturday 13 · meet Bayswater ⊖ £5 B412 with this fly ·

This is the top one!
DJs Lennie Dee, Groove Rider, Ellis D + guests.
Light show, film, bouncy castle, special f.x, 7K system, house, soul, baleric, alternative. wicked chill out lounge, toilets, powder rooms, snax, sweets and suprises + lots more.

love Unit 4 x x
ps. pilot on standby from 11 p.m.

BAYSWATER
TUBE STN
LONDON
W2

LOVE
// May 1989 // Unit 4 presents // Warehouse Party
// Bayswater, London W2

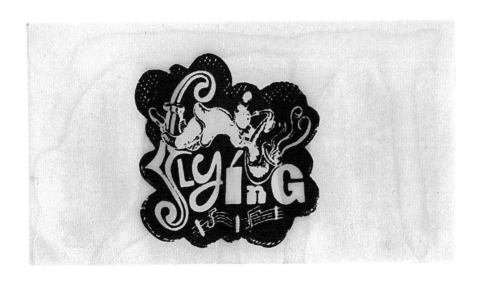

The Soho Theatre Club

EVERY SATURDAY
FROM 12th MAY 10pm — 3am
ADMISSION : £8.00

RESIDENT DJs
PHIL PERRY
DEAN THATCHER
DAVE BEGGARS

P L U S G U E S T S . . .
MAY 26th
TERRY FARLEY
JUNE 2nd
DAVE
FROM BEGGARS
JUNE 9th
CRAIG WALSH
NICK & ASHLEY
FROM ECLIPSE
JUNE 16th
NICK & ASHLEY
STUART BROTHERS
FROM TENERIFE

8-9 FALCONBERG COURT
(BEHIND BUSBY'S — TOTTENHAM COURT RD.)

FLYING
// May 1989 onwards // Soho Theatre Club presents
// Falconberg Court, Tottenham Court Road, London W1

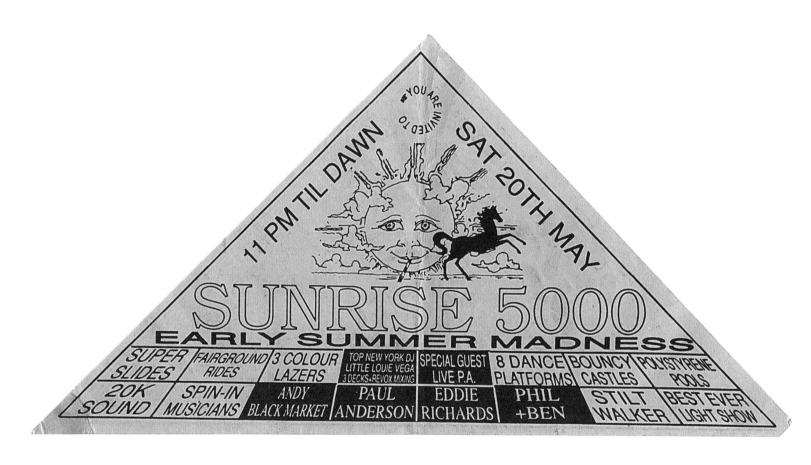

SUNRISE 5000
// May 1989 // Early Summer Madness // Once in a Blue Moon
// Santa Pod race track, Northhamptonshire

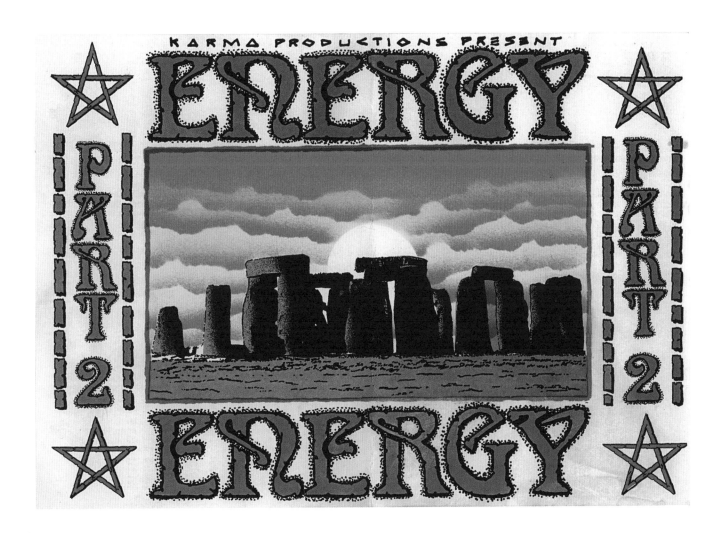

ENERGY PART 2
// May 1989 // Karma Productions
// Membury, Berkshire

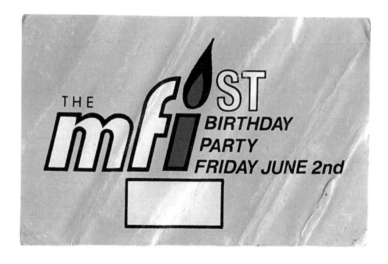

CLUB MFI
// Circa 1989 // Membership card // A Neville and Spike production
// Legends, Old Burlington Street, London W1

CLUB MFI
// June 1989 // 1st Birthday invite // A Neville and Spike production
// Legends, Old Burlington Street, London W1

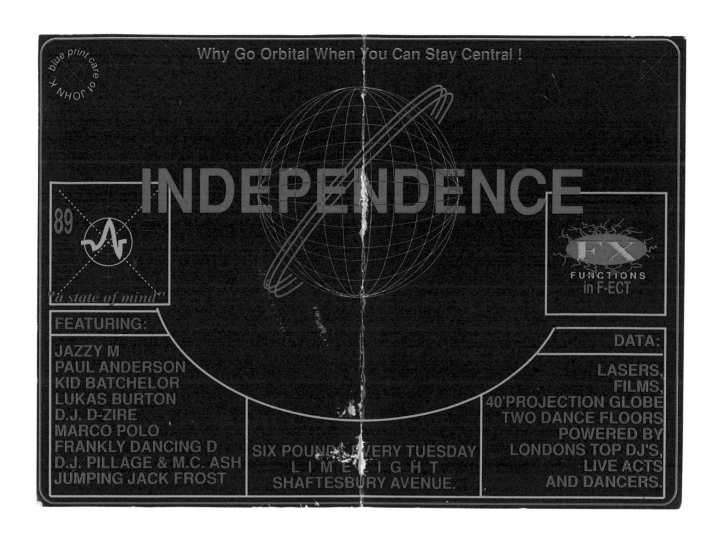

Why Go Orbital When You Can Stay Central !

blue print care of JOHN K.

INDEPENDENCE

89

"a state of mind"

FX
FUNCTIONS
in F-ECT

FEATURING:

JAZZY M
PAUL ANDERSON
KID BATCHELOR
LUKAS BURTON
D.J. D-ZIRE
MARCO POLO
FRANKLY DANCING D
D.J. PILLAGE & M.C. ASH
JUMPING JACK FROST

SIX POUNDS EVERY TUESDAY
L I M E L I G H T
SHAFTESBURY AVENUE.

DATA:

LASERS,
FILMS,
40'PROJECTION GLOBE
TWO DANCE FLOORS
POWERED BY
LONDONS TOP DJ'S,
LIVE ACTS
AND DANCERS.

INDEPENDENCE
// June 1989 onwards
// Limelight, Shaftesbury Avenue, London W1

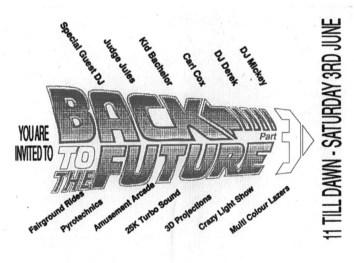

YOU ARE INVITED TO

Special Guest DJ · Judge Jules · Kid Bachelor · Carl Cox · DJ Derek · DJ Mickey

BACK TO THE FUTURE *Part 3*

Fairground Rides · Pyrotechnics · Amusement Arcade · 25K Turbo Sound · 3D Projections · Crazy Light Show · Multi Colour Lazers

11 TILL DAWN · SATURDAY 3RD JUNE

ADMITTANCE ▲ STRICTLY TICKET HOLDERS ONLY ▲ PRIVATE PARTY ▲

DONATIONS TO GREENPEACE

LONDON

South	North	Central	West
01-674 3287	01-833 8346	01-437 0478	01-968 5055
Dave	Denzil	Black Mkt.	Linda

Camden	Wembley	Greenford	Ealing	Bromley	Edgware
01-485 2608	01-900 0268	01-423 6519	01-567 3880	01-460 6428	01-906 2183
Charlie	Simon	Lynn	James	Nick	Finbar

REGIONAL

Southend	Brighton	Upminster	Westerham	Aylesbury
0702 345859	0273 27857	0402 225170	0737 222489	0296 435548
Dave	Carl	Ian	Andy	Mark

Milton Keynes	Colchester	Luton	Heathrow	Slough	Grays
0908 647632	0206 44055	0582 422534	0932 846143	0941 101113	0708 861764
Gerri	Giles	Brendon	Andy	John	Joe

You are invited by Back to the Future Club Member
No. _____

Limited Ticket Qty.
Collect your tickets Before 1st to avoid disappointment

Dial-a-rave
Every Saturday night on...
01-725 9764 - 20 lines
or direct to the venue on
0860 235411 ™ 0860 824567 ™ 0836 699461
For party info.

Exciting new **VENUE** (nearer to London)

Membership info
01-734 4801 Mandy or page us your address for application form
No. 01-840 7000/080 1039

..STOP PRESS: NEXT SUNRISE 24th JUNE...STOP PRESS: NEXT SUNRISE 24th JUNE.

BACK TO THE FUTURE
// June 1989 // Dave Roberts Promotions
// Buckinghamshire

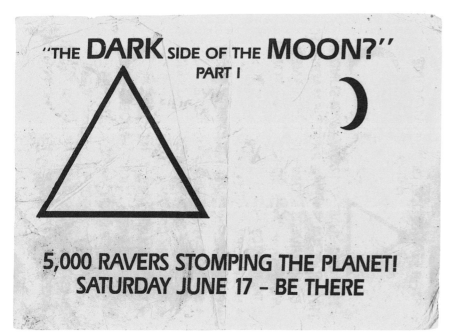

"THE DARK SIDE OF THE MOON?"
PART I

**5,000 RAVERS STOMPING THE PLANET!
SATURDAY JUNE 17 – BE THERE**

"THE DARK SIDE OF THE MOON?"
PART I

1989 SAT JUNE 17 12AM – 6PM SUNDAY
(18 HOURS RAVING) THE RAVE OF MADNESS!
5,000 RAVERS STOMPING THE PLANET!
A BRING → "THE NOISE PROMOTION"!
★ THE TOP 20 DJs + LAZARIUM - DAZZLING EFFECTS
★ HELICOPTER + AEROPLANE RIDES
★ COMPLETE FUNFAIR + AMUSEMENT PARK
★ SATTELITE TV + VIDEO LOUNGES
★ LIVE P.A's + 3 VIP AND CELEBRITY LOUNGES
★ FIREWORK DISPLAY
★ TURBO SOUND SYSTEM - (MASSIVE)
LIMITED ENTRY - TICKET HOLDERS ONLY
- PRIVATE PARTY - HOTLINE DETAILS -
NORTH SOUTH EAST WEST
01-839 0005 01-291 1074 01-739 1841 01-741 2753
ACCESS AMEX VISA ACCEPTED PHONE NOW!

DARK SIDE OF THE MOON PART I
// June 1989 // 'Bring the Noise' promotion
// Elstree, Hertfordshire

NIRVANA
TICKET
admits one only

MANAGEMENT RESERVE THE RIGHT TO REFUSE ADMISSION

TICKET NO. 467

NIRVANA
// Circa June 1989
// Cambridgeshire

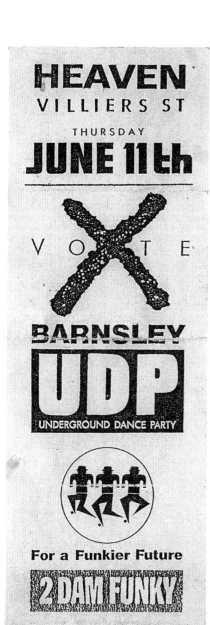

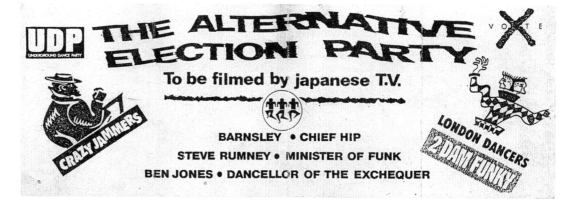

UDP
// June 1989 // Underground Dance Party promotes
// Heaven, Villiers Street, London WC2

HARDER THEY COME

.............PRESENT.............

RENAISSANCE!!

SUMMER — ALL DAYER — SUMMER
★ 9 HOURS OF MUSICAL MADNESS ★

HARDER THEY COME

SOUND
PAUL ANDERSON
TREVOR FUNG
SHIVER (IBIZA)
UBIQUITY (TOTO)
EDDIE RICHARDS
STEVE PROCTER
AND MORE!!

SURROUNDINGS
LAZERSHOW
LIGHTING
PROJECTIONS
POOL TABLE
+ FAIRGROUND
RIDES
ICE CREAM
POPCORN+++

START – 3.00 P.M. FINISH – 12 MIDNIGHT

SUNDAY 11TH JUNE 1989
CRAZY LARRY'S
533 KINGS ROAD, LONDON SW6.
PLEASE ARRIVE EARLY TO ENSURE ENTRY

TICKETS
£8 B4 6PM
£10 THEREAFTER

INCLUDES
FREE
MEMBERSHIP

RENAISSANCE
// June 1989 // Harder They Come promotions
// Crazy Larry's, Kings Road, London SW6

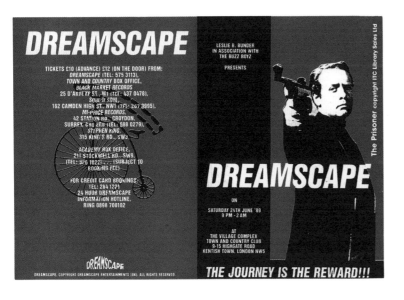

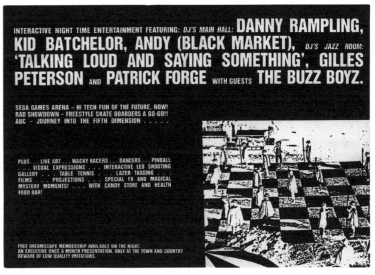

DREAMSCAPE
// Leslie Bunder and the Buzz Boys present
// The Village Complex, London NW5

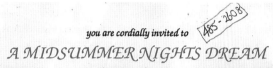

you are cordially invited to

A MIDSUMMER NIGHTS DREAM

485 - 2608

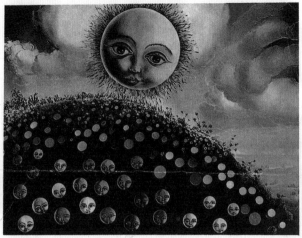

on *MIDSUMMER NIGHT*, **SAT 24th JUNE**

THE MOST SPECTACULAR EVER

Supernatural Suspense S U N R I S E *Magical Mystery*

10pm - 10am, 12 Hours of midsummer magic

TURNTABLE WIZARDS

EDDIE RICHARDS • JUDGE JULES
TREVOR FUNG • PAUL ANDERSON
FRANKIE VANTINE • FABIO

MUSICAL MAGICIANS
LIVE P.A. : RAM JAC
MASTER of CEREMONIES: Mr C.
Gordon & the Magic Trumpet

▲ **PRIVATE PARTY** *for SUNRISE & BACK TO THE FUTURE Members and their guests only*

ADMISSION STRICTLY BY TICKET ONLY

L O N D O N T I C K E T A G E N T S

South	North	Central	West
01-674 3287	01-833 8346	01-437 0478	01-607 7665
Dave	Denzil	Black Mkt.	Tosh

Camden	Wembley	Greenford	Ealing	Bromley	Fulham
01-485 2608	01-900 0268	01-423 6519	01-567 3880	01-460 6428	01-736 0073
Charlie	Simon	Lynn	James	Nick	Natasha

R E G I O N A L T I C K E T A G E N T S

Southend	Brighton	Romford	Croydon	Aylesbury
0702 345859	0273 27857	0402 225170	0737 222489	0296 435548
Dave	Maxine	Ian	Andy	Mark

Milton Keynes	Colchester	Luton	Heathrow	Slough
0908 647632	0206 44055	0582 422534	0932 846143	0941 101113
Gerri	Giles	Brendon	Andy	John

Faversham	Manchester	Bracknell	Welwyn G. City	Grays
0795 537521	061 7375487	0344 860778	0707 339453	0708 861764
Tinni	Chris	Stephen	Alex	Joe

Qty Ticket Orders 0860 235411 Late Tickets? 01-485 2608

DUE TO POPULAR DEMAND, TICKETS WILL NOT BE AVAILABLE AFTER THURS 22nd

TICKETS ARE NOT AVAILABLE AT THE DOOR

ATTN: BEWARE OF TICKET FORGERIES
ONLY TRUST APPOINTED TICKET AGENTS
MEMBERSHIP INFO 01-725 9764 GENERAL INFO 01-725 7081

This invitation allows you up to four tickets. To obtain your tickets
you must complete the form below to give to your local ticket agent

I REQUIRE 1 2 3 4 TICKETS	GUEST OF MEMBER Nº.

FULL NAME: ..

ADDRESS: ..

.....................................

PHONE NO.

SUNRISE
// June 1989 // Dave Roberts promotions // Sunrise and Back to the Future
// 'A Midsummer Night's Dream' // White Waltham Airstrip, Maidenhead

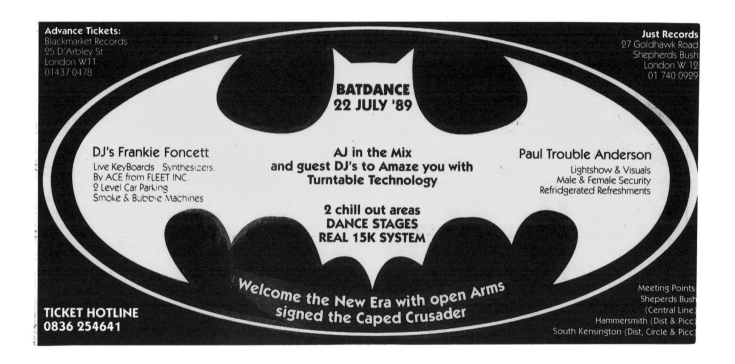

BATDANCE
// July 1989 // Caped Crusader Productions
// West London

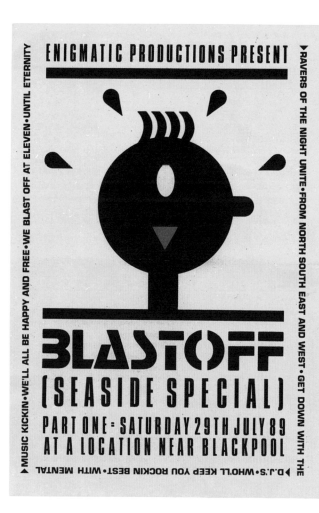

ENIGMATIC PRODUCTIONS PRESENT

BLASTOFF
(SEASIDE SPECIAL)

PART ONE = SATURDAY 29TH JULY 89
AT A LOCATION NEAR BLACKPOOL

▶ MUSIC KICKIN'•WE'LL ALL BE HAPPY AND FREE•WE BLAST OFF AT ELEVEN•UNTIL ETERNITY

▶ RAVERS OF THE NIGHT UNITE•FROM NORTH SOUTH EAST AND WEST•GET DOWN WITH THE

▶ D.J.'S WHO'LL KEEP YOU ROCKIN BEST•WITH MENTAL

A STAR STUDDED LINE UP OF TOP D.J.'S ON FOUR SOUND SYSTEMS

CRISS ANGEL LONDON	PAUL TROUBLE ANDERSON LONDON (SUNRISE)
CESARE SARDINIA	B.B.BAD /PHIL PERRY LONDON
HARVEY/CHOCCY LONDON (FREETOWN)	JAM M.C.'S MANCHESTER
JON DASILVA MANCHESTER (HACIENDA)	BONES LONDON (LIVEWIRE)
ROSCOE LONDON (SOLARIS)	D.J. SOPHIE LONDON (FREEDAM)
KID BATCHELOR LONDON (CONFUSION)	EWAN CLARK MANCHESTER (HACIENDA)

PLUS P.A.'S BY CYBERTRON (LATEST RELEASE I DELIVER) M.C. KINKY, EZEE POSSE, OF EVERYTHING BEGINS WITH AN 'E' FAME

ATTRACTIONS

20 KS OF SOUND		EXOTIC DANCERS
SWEET BAR	CLOTHES STALL	BOUNCY CASTLES
CHILL OUT AREA		MINDSCAPES THE VISUALS

LASERS, ANIMATIONS & DRY SMOKE BY DYNAMIC LASERS

NORTH AND SOUTH UNITED • THIS IS THE BIG ONE A TOTALLY LEGAL RAVE WITH FIRE OFFICER ON SITE

TICKET INFORMATION
TICKET PRICE £10.00 (INC MEMBERSHIP) BEFORE 20.7.89
£15.00 (INC MEMBERSHIP) THERE-AFTER

TICKET AGENTS
BLACK MARKET RECORDS D'ARBLAY STREET LONDON W1 TEL: 01-437 0478
SOUL II SOUL 162 CAMDEN HIGH STREET, LONDON, NW1 TEL: 01-267 3995

NORTH LONDON	WEST LONDON	SOUTH LONDON	NORTH EAST LONDON
TEL:267 8214	TEL:960 8988	TEL: 737 8044	TEL: 01-802 2489

COACHES: TO BE BOOKED BEFORE 20.7.89
DETAILS FROM YOUR TICKET AGENT. PRICE £17.50 RETURN

LIMITED AMOUNT OF TICKETS AVAILABLE SO PLEASE BOOK EARLY TO AVOID DISAPPOINTMENT.
REMEMBER BLAST OFF IS A PRIVATE PARTY FOR TICKET HOLDERS ONLY NO TICKET NO ENTRY

HIP HOUSE•GARAGE•WORLD BEATS•LATIN•BALEARIC
DEEP HOUSE • FREESTYLE • TECHNO • NEW BEAT

BLAST OFF (SEASIDE SPECIAL)
// July 1989 // Enigmatic Productions present
// Near Blackpool

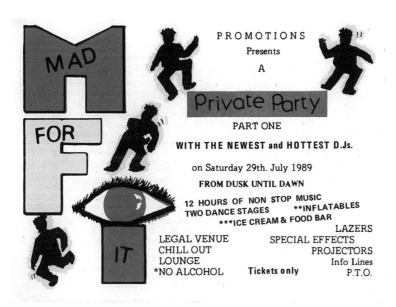

M.A.D FOR F IT

PROMOTIONS
Presents
A

Private Party

PART ONE

WITH THE NEWEST and HOTTEST D.Js.

on Saturday 29th. July 1989

FROM DUSK UNTIL DAWN

12 HOURS OF NON STOP MUSIC
TWO DANCE STAGES ***INFLATABLES**
***ICE CREAM & FOOD BAR**

LAZERS

LEGAL VENUE SPECIAL EFFECTS
CHILL OUT PROJECTORS
LOUNGE Info Lines
*NO ALCOHOL **Tickets only** P.T.O.

It's very rare to find a promotion company that their 1st. bash is a big one. M.F.I. have been going to other do's and planning this one for a long time. What we've got for you is a well organised event, on a large plot of English countryside, "The best of both worlds" should be the title for this one, half enclosed and half open-air. There's only a limited number of tickets (5,000) so get phoning now.
———————————— P.S. M.F.I. HAVE A GOOD ONE. ————————————

TICKET AGENTS :- OUTER LONDON
Victoria Tickets Danielle 01-828 0084
Watford Past & Present Records (0923) 32772
Watford : Gaz (0923) 776814
Portsmouth : Rick (0705) 811541
Luton : Record City (0582) 20423
Ilford : Music Power 01-478 2080

INNER LONDON:-
Edmonton Yvonne 01-803 0967
Tottenham Tony 01-800 3669
Haringey Tony 01-341 2355
.. Music Power 01-800 6113
Islington Louis Menswear 01-837 0005
Palmers Green Clive 01-881 5726
Southgate Debbie 01-441 3359
Brixton Red Records 01-274 4476
Wimbledon Jane 01-947 1566
Between : 6.00.p.m. - 10.00.p.m.

D-Js. ********
* Alistair (Crazy Larry's & Wag)
* Cleveland Anderson
* Ron Tom & Chanelle
* Vicki Edwards (Browns)

* Bad Boy West (Sunrise F,M,)
* Tully
* Plus P.A. by Adamski The Keyboard Wizard
 & Music by our own D.J. Dr. DOT to DOT M.F.I. F.M.

WEST LONDON: Get Fresh Records 01-969 3155
SOHO: Red Records and Black Market Records
 01-734 2746 / 01-437 0478

TICKETS VALID FROM THESE
OUTLETS ONLY

Information Line 0836 537-135

MAD FOR IT PART ONE
// July 1989 // MFI Promotions
// Buckinghamshire

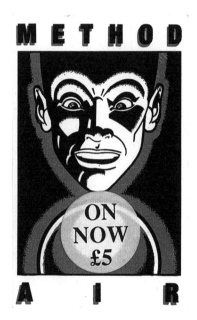

METHOD AIR
MUSIC MAKERS

PAUL ANDERSON
JUDGE JULES
BEN + ANDY
+ GUESTS

FRIDAY 28th JULY
11pm 'TILL DAYBREAK

TWIN DANCEDIVES
DUAL HI' POWER SOUND
SK8 RAMP
TAPAS ESPANOL
3RD EYE VISUALS

THE ARCH 66 GODING STREET
OFF ALBERT EMBANKMENT

£7 FEISTY !

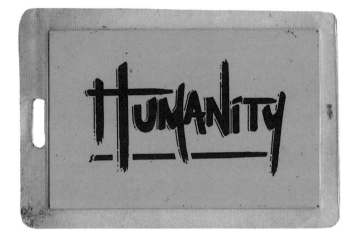

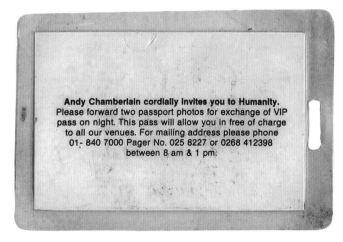

Andy Chamberlain cordially invites you to Humanity.
Please forward two passport photos for exchange of VIP
pass on night. This pass will allow you in free of charge
to all our venues. For mailing address please phone
01- 840 7000 Pager No. 025 8227 or 0268 412398
between 8 am & 1 pm.

METHOD AIR
// July 1989
// The Arch, Goding Street, London SE11

HUMANITY
// Circa 1989 // VIP membership card // Andy Chamberlain promotions
// All venues

BOILERHOUSE . . .

METHOD AIR

The Nadir is over . . .

MUSIC MAKERS
Frankie ● Paul Anderson ● Kid Batchelor
and Special Guests

SPHERE OF INFLUENCE

SK8 HALF PIPE AND MINI RAMP
TAPAS BAR ● CASBAH CRASH DEN
CHAMPAGNE BREAKFAST

Friday July 7th ● 10pm-All Night

Tickets in advance £7
Available from Boy, Moor St. Soho
£10 on the door

Fortnightly The Arch, 66 Goding St. SE11

METHOD AIR
// July 1989
// The Arch, Goding Street, London SE11

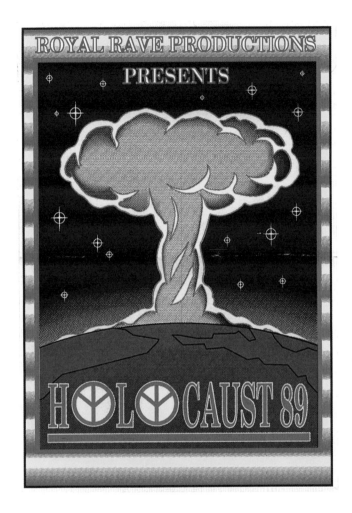

ROYAL RAVE PRODUCTIONS
PRESENTS

HOLOCAUST 89

SATURDAY THE 29th OF JULY

TOP TEN CLUB & UNDERGROUND DJ'S FROM DETROIT,
NEW YORK & CHICARGO. PLUS GUEST DJ'S FROM LONDON
& LIVE PA'S.

NOISE 30K TURBO SOUND.

VISUALS- THE MOST SPECTACULAR LIGHTING & THREE
COLOUR LASER SHOW EVER TO BE WITNESSED.

SPECIAL FEATURES- FULL FUN FAIR INCLUDING DOGEMS,
TWO V.I.P. LOUNGES, TWO BARS, FREE BARBEQUE,
ICE CREAM & FRUIT PARLOUR. PLUS VIDEO AMUSEMENTS.

THIS IS A PRIVATE PARTY, ENTRANCE BY INVITATION
ONLY. IT IS TO BE HELD IN OUR OWN PREMISES & ON OUR
OWN LAND. 35 MINUTES FROM CENTRAL LONDON.

THIS IS LEGAL & CANNOT BE STOPPED. TICKETS WILL
ONLY BE SOLD TO PEOPLE WHO WE FEEL ARE WELCOME,
DUE TO PRESENT CIRCUMSTANCES.

FOR TICKETS & FURTHER INFORMATION RING:

0860 27 9059 OR 0860 57 9211

GUARANTEED TO BE THE BIGGEST & MOST SPECTACULAR PARTY EVER

HOLOCAUST 89
// July 1989 // Royal Rave Productions
// Essex

THIS SUNDAY 27TH

UNITY PRODUCTIONS
AND
RED KAMEL
PRESENTS A PRIVATE PARTY....
AT
THE DRAMA HALL PRINCE OF WALES ROAD.....
CAMDEN... CHALK FARM N W 3

THIS SUNDAY 27TH

D.J'S FAT TONY
FRANKIE.G
BIZ.E.B
RUPPEE AND THE REGGAE MASTER

11=EARLY HOURS

UNITY REGULARS...EVERSON AND 'THE RAT PACK ALLEN'

TELEX

BACK TO THE FUTURE
// Circa 1989 // VIP membership pass
// All events

UNITY PRIVATE PARTY
// Mid-1989 // Unity Productions and Red Kamel
// Drama Hall, Chalk Farm, London NW1

YUM-YUM
// Circa 1989
// Soho Theatre, Falconberg Court, London W1

UPRISING
// Mid-1989 // Judge Jules
// The Starlight, Praed Street, London W2

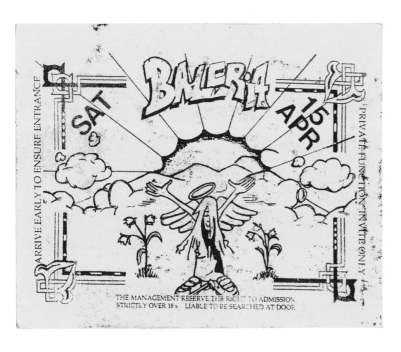

BALERA
// April 1989

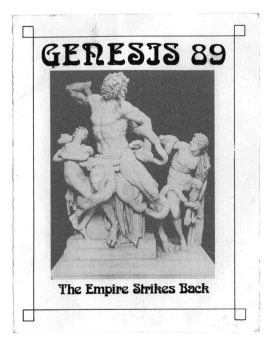

GENESIS 89

The Empire Strikes Back

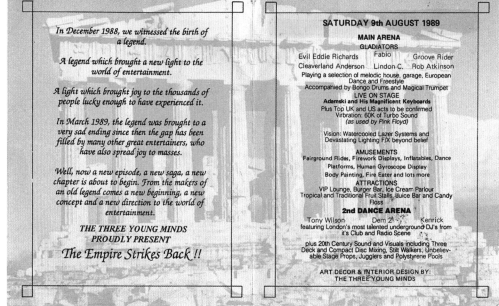

In December 1988, we witnessed the birth of a legend.

A legend which brought a new light to the world of entertainment.

A light which brought joy to the thousands of people lucky enough to have experienced it.

In March 1989, the legend was brought to a very sad ending since then the gap has been filled by many other great entertainers, who have also spread joy to masses.

Well, now a new episode, a new saga, a new chapter is about to begin. From the makers of an old legend comes a new beginning, a new concept and a new direction to the world of entertainment.

THE THREE YOUNG MINDS PROUDLY PRESENT

The Empire Strikes Back !!

SATURDAY 9th AUGUST 1989

MAIN ARENA

GLADIATORS

Evil Eddie Richards Fabio Groove Rider
Cleaverland Anderson Lindon C. Rob Atkinson

Playing a selection of melodic house, garage, European Dance and Freestyle
Accompanied by Bongo Drums and Magical Trumpet

LIVE ON STAGE
Adamski and His Magnificent Keyboards
Plus Top UK and US acts to be confirmed
Virbration: 60K of Turbo Sound
(as used by Pink Floyd)

Vision: Watercooled Lazer Systems and Devastating Lighting F/X beyond belief

AMUSEMENTS
Fairground Rides, Firework Displays, Inflatables, Dance Platforms, Human Gyroscope Display
Body Painting, Fire Eater and lots more

ATTRACTIONS
VIP Lounge, Burger Bar, Ice Cream Parlour
Tropical and Traditional Fruit Stalls, Juice Bar and Candy Floss

2nd DANCE ARENA

Tony Wilson Dem 2 Kenrick
featuring London's most talented underground DJ's from it's Club and Radio Scene

plus 20th Century Sound and Visuals including Three Deck and Compact Disc Mixing, Stilt Walkers, Unbelievable Stage Props, Jugglers and Polystyrene Pools

ART DECOR & INTERIOR DESIGN BY:
THE THREE YOUNG MINDS

GENESIS 89
// August 1989
// The Empire Strikes Back

Genesis

TRANQUILITY

GENESIS '89'
The Legend

Four months ago in the depths of London, three young men's dreams became reality and joy was given to thousands of people. Think back to a venue in East London where Christmas was wonderful and the New Year began. REMEMBER two floors of mystery and spectacular lighting in North London - alongside a quiet lake - A lazer filled warehouse rocked.
We all have our memories, ours are called GENESIS.
We deeply regret the inconvenience to our people, caused by the jealousy of others, but together, with you the people behind us,

The Empire Will Strike Back.
Summer of Love
Winter of Joy
Year of Genesis

Genesis '89'

FIRST PERMANEANT VENUE AT
ECHOES
NIGHT SPOT
Bow Road, Stratford E15.
Every Wednesday
9.00pm till 2.am
Come Early To Ensure Entry
LONDON'S TOP D.J's
Lazer Lighting
& Turbo Sound

MEMBERSHIP NOW AVAILIBLE

THE MANAGEMENT RESERVE THE RIGHT
TO ADMISSION ☞ STRICTLY OVER 18's

GENESIS 89
// Circa July 1989 // 'Tranquility'
// Echoes, Bow Road, Stratford E15

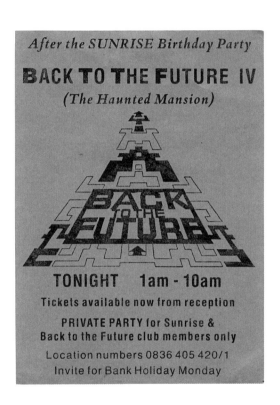

BACK TO THE FUTURE IV
// August 1989 // Members party
// The Haunted Mansion

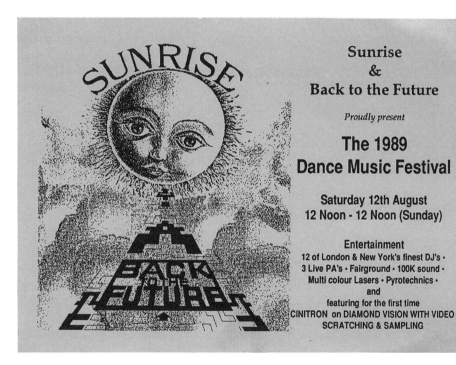

SUNRISE
// August 1989
// Dance Music Festival

ONE NATION
HISTORY IN THE MAKING

Saturday 12th August 1989
At a film studio in London

FEATURING DJ's
PAUL OAKENFOLD • EDDIE RICHARDS • DEM2
GROOVE RIDER • STEVE BICKNELL • FABIO
LIVE PA'S TO BE CONFIRMED

This event is to be filmed for satellite TV. we will have interviews with DJ's, artists and you the people to show the truth about House Music and set the record straight.

Tickets limited to 4000 and will go on sale from 20th July to 10th August. Tickets priced £12 before 3rd August £15 after. No one under the age of 18 permitted to buy tickets. Proof of age maybe required.

TICKET AGENTS
SOUTH - Dave 01-228 4178 (24 hours)
CENTRAL - Black Market 01-437 0478
NORTH - Finbar 01-906 2183
For additional ticket agents in your area phone info line 0860-827695.
This is a PRIVATE PARTY for One Nation members and their guests only.

Invited by:

Quantity and late tickets
INFO LINE 0860-827695
No money will be accepted on the door.
Admission strictly by ticket only.

DESIGN:ART21

ONE NATION
// August 1989 // One Nation promotions
// West London Film Studios

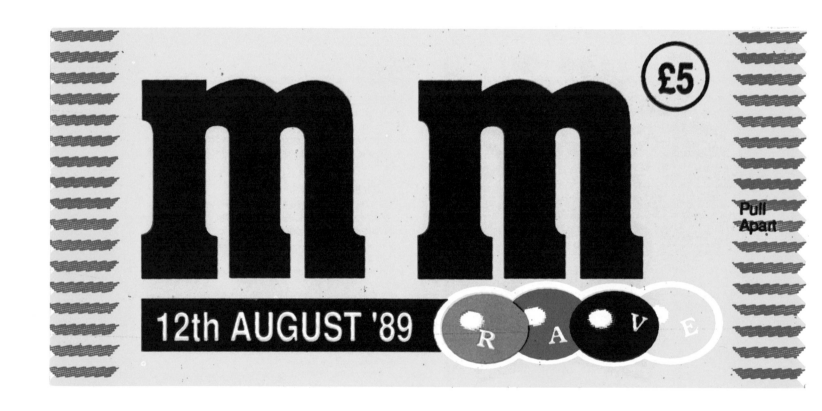

MM
// August 1989 // Manasseh promotions
// The Town and Country Club, London NW2

TICKETS AVAILALE FROM:
TOWN & COUNTRY CLUB 9 HIGHGATE Rd. N.W.5 284 0303
QUAFF NR PORTOBELLO Rd. & LANCASTER Rd. W.11 792 0068
SOUL II SOUL 162 CAMDEN HIGH St. N.W.1 482 2697
RED 47 BEAK St. LONDON W. 1 734 2745
BLACK MARKET 25 D'ARBLAY St. SOHO W.1 437 0478
VINYL ZONE 112 NEW KINGS Rd. S.W.6 384 2320

SATURDAY 12TH AUGUST 1989, 9 TILL LATE

NAME: _____

ADDRESS: _____

HAND IN AT THE VENUE ON THE NIGHT
OR SEND TO 61 LANCASTER Rd. W.11 1QG

MEMBERSHIP APPLICATION

NUTRITION INFORMATION
THIS RAVE GIVES YOU
NOEL WATSON, PAUL 'TROUBLE'
ANDERSON, JUDGE JULES, MARCO
MILLITELLO (DEVOTION ROME),
ROY 'THE ROACH',
MANASSEH HI-POWER
GUEST LIVE APPEARANCE TO CONFIRM

INGREDIENTS: TURBO SOUND 'TO PROVIDE BASS IN
THE PLACE', FIREATERS, STILT WALKERS,
JUGGLERS, ILLUTIONISTS, MAGICIANS, MIME ARTISTS,
FREAKS, FREE....FRUIT BAR, JAMBOREE BAGS,
ICES, SWEETIES, CANDY FLOSS & WE HOPE TO FIND
SPANGLES

TICKETS £5 IN ADVANCE £7 ON THE DOOR

MAIN ARENA+BEAT THEATRE, 2 FLOORS OF FUN

The Town & Country Club, 9 Highgate Rd. N.W.2

//111

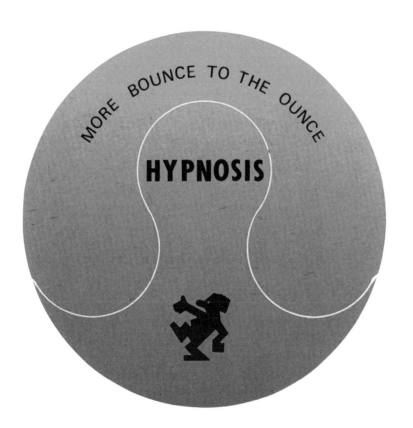

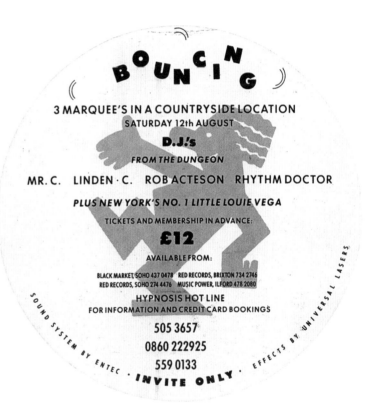

HYPNOSIS
// August 1989 // Bouncing present
// In a field near Northampton

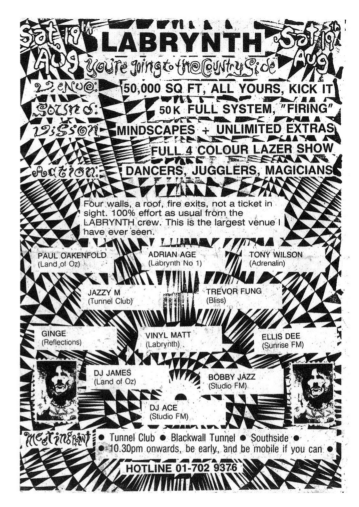

LABRYNTH
// August 1989 // Joe Wieczorek presents
// Meeting point, Tunnel Club

UNIT 4 Presents 'FRENCH KISS'

COLCHESTER - MARTIN - MILTON - KEYNES KEV - BASILDON

SATURDAY 12 AUGUST 1989

AS SEEN ON T.V

PRIVATE PARTY-TICKET HOLDERS ONLY-NO MONEY ON THE DOOR

UNIT ⓔ 4 **THE NATION**

EVERY TICKET IS V.I.P FREE DRINK + LIGHT STICKS
NO RESTRICTIONS COACHES AVAILABLE

FULL SATISFACTION OR MONEY BACK GUARANTEE

MUSIC ☞ TOP 10 D.J's FROM SUMMER '88
PLUS GUESTS FROM '89

LIVE PA ☞ ADAMSKI + LIVE RAPPING OZZIE GEE

SOUND ☞ LOUD MUSIC TO YOUR EARS-
NO BULL JUST PUKKA

LIGHTING ☞ **BLINDING** FROM THE SKIES
TO YOUR EYES

VENUE ☞ **OUT OF THIS WORLD**
BUT NOT TOO FAR

ENTERTAINMENTS ☞ RIDES-GO-KARTS-WET-BIKES
PLUS SURPRISES

WORKOUT ☞ MUSCLE IN MOTION

FOR TICKETS AND AGENTS IN YOUR AREA
RING **01-528 9001** ASK FOR
PAGER NO: 806-531 THEN LEAVE YOUR NAME AND
TELEPHONE NUMBER AND WE WILL CONTACT YOU ASAP

ATTENTION! *ALL TICKETS PURCHASED IN JULY-33% DISCOUNT*
FIRE OFFICER/CROWD CONTROLLERS ON SITE - CAR PARKING
NO *GUTTER PRESS* NO *DRUG DEALERS* NO *OLD BILL*

ANDY HEATHROW TONY - IPSWICH - LORRAINE LOUGHTON - NICKY BROMLEY

JACQUI - CLACTON SID PORTSMOUTH - BRENDON LUTON

AGENTS - LONDON NORTH - EAST - SOUTH - WEST - REGIONS - GILES/GREG -

FRENCH KISS
// August 1989 // Unit 4 presents
// Essex

NICK TRULOCKE PRESENTS AN UNDERGROUND RAVE
SATURDAYS OFFICIAL OPENING NIGHT AUG 5. 1989 10.30 PM – 3.30 AM

DESIRE!

ADMISSION TICKET HOLDERS £5 **FEATURING DJ's LEE & PAUL GIBSON** WITHOUT TICKET £6
THE BASEMENT 79 OXFORD ST. RIGHT OF ADMISSION RESERVED

DESIRE!
// August 1989 // Nick Trulocke presents
// Oxford Street, London W1

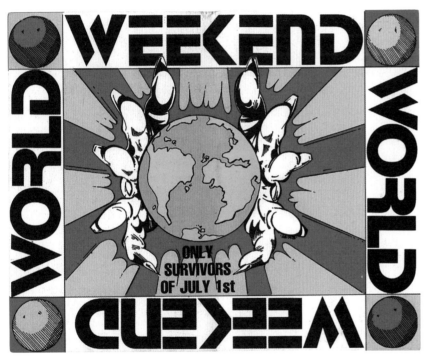

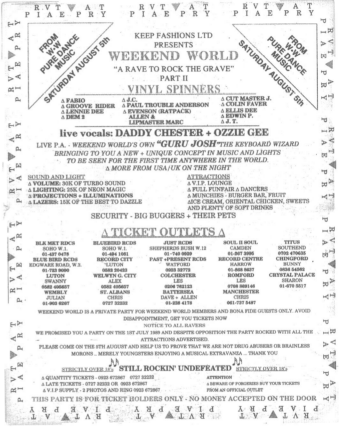

WEEKEND WORLD
// August 1989 // Keep Fashions Ltd presents
// 'A Rave to Rock the Grave Part II' // Outside London

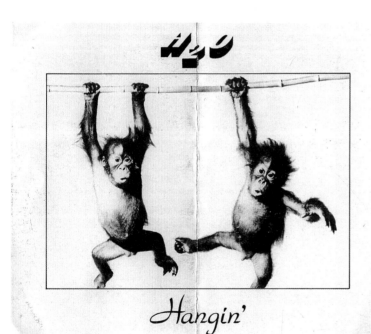

H2O

Hangin'

H2O **H2O**

Hangin'

| The Ultimate | Saturday 19th August 1989 | Private Party |
| Dance Experience! | Midnight till Dawn | Ticket Holders Only |

Attractions

20K Turbo Sound ✮ Spectacular Light Show ✮ 3 Turntables
Fruit & Juice Bar ✮ Hamburger & Popcorn Stalls ✮ 3 Dance Platforms
VIP Room ✮ Crash Lounge ✮ Belly Dancers ✮ Live P.A.

Vinyl Wizzards

Craig Walsh ✮ Fabio ✮ Andy Nicholls ✮ Obsession ✮ Dem 2 ✮ Steve Proctor
Rocky 'n' Diesel ✮ Brains ✮ & Special Guests

Venue

20 minutes from Central London

Tickets

Black Market Records, 25 D'Arblay Street, Soho, London W1. Tel: 01-437 0478
Just Records, 27 Goldhawk Road, Shepherds Bush, London W12. Tel: 01-740 0929
Quaff Records, Lancaster Road, London W11. Tel: 01-792 0068

H_2O stress this is a select venue for a select crowd

HANGIN'
// August 1989 // H2O promotions
// A venue west of London

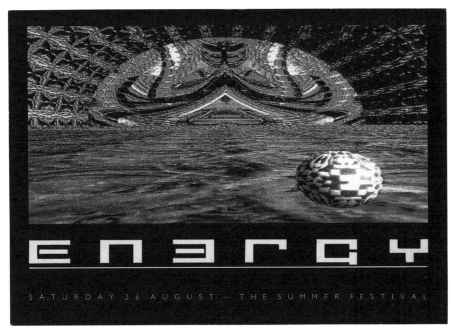

KARMA PRODUCTIONS PRESENT

ON SATURDAY 26TH AUGUST 1989

ENERGY
THE SUMMER FESTIVAL

ON SATURDAY 26TH AUGUST 1989

MUSIC

FABIO *PAUL OAKENFOLD* *JUDGE JULES*
EVIL EDDIE *STEVE BICKNELL* *BONES*
FRANKY *DEM 2* *NICK HOLLOWAY*

SPECIAL GUEST D.J. FROM NEW YORK: FRANKY BONES

— PLUS LIVE GUEST APPEARANCES —

On the night we will undertake to entertain with an even higher degree of sound (40K) Lighting (Varylight Systems) Lazers (4 different water cooled 7 colour systems) and decorations higher than our normal standards. There will also be Live P.A.'s, jugglers, magicians, and an assortment of funfair rides and games to keep you amused. Refreshments, food and snacks will be available through the night including burger bars, fruit, fresh coffee, ice creams, candy floss and popcorn.

TICKET AGENTS

*FULHAM / CHELSEA: 01-736 6390 Tin Tin. BRIXTON: 01-674 3287 Paul & Dave.
ROMFORD: 0708 861 764 Jo. ESSEX: 0206 44055 Giles. SOUTH EAST: 01-703 0628 Sam.
SOUTHEND: 0702 470635 Dave. NORTH: 0707 339 453 Alex. EAST: 01-739 1841 Carlos.
WEMBLEY: 01-903 6267 Julian. WATFORD: 0836 548504 Steve & Gary.
PORTSMOUTH: 0705 811541 Rick.*

OFFICIAL KARMA PRODUCTIONS TICKET OUTLETS

*Ticket Collection: KARMA PRODUCTIONS, 1 FULHAM HIGH STREET LONDON SW6.
There will be no booking fee from Karma Productions, but there will be a £1 booking fee on each ticket from the below outlets.
BLACK MARKET RECORDS, 25 D'ARBLAY ST, SOHO, W1.
MUSIC POWER, 37 GRAND PARADE, GREEN LANES, HARINGAY, N4.*

*ALL TICKETS MUST BE PURCHASED IN ADVANCE. NO TICKETS WILL BE AVAILABLE ON THE DAY.
STRICTLY INVITE ONLY. THIS IS A PRIVATE PARTY FOR KARMA MEMBERS AND FRIENDS
AND WILL BE FILMED FOR FUTURE PUBLIC BROADCAST.*

ENQUIRIES AND CREDIT CARD BOOKINGS
01-384 2060 or 01-736 6390

MAIL ORDER: Send to KARMA PRODUCTIONS, 1 FULHAM HIGH STREET, LONDON SW6 1JH.

- -

please send me.................membership at £15 each

I enclose a cheque/postal order for £.......................made payable to karma productions

NAME:..

ADDRESS:...

POSTCODE:.......................................TELEPHONE:.............................

ENERGY
// August 1989 // The Summer Festival // Karma Productions
// Effingham, Surrey

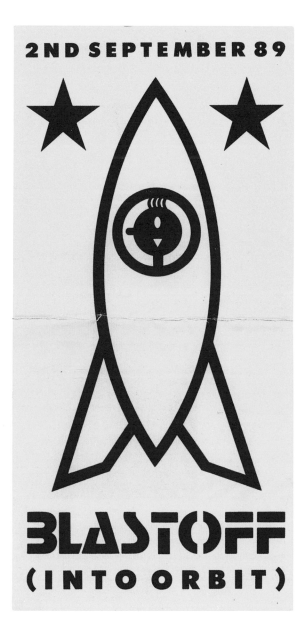

2ND SEPTEMBER 89

BLASTOFF
(INTO ORBIT)

AFTER THE SUCCESSFUL BLAST OFF SEASIDE SPECIAL WE PRESENT BLAST OFF INTO ORBIT. A TWELVE HOUR MUSICAL AND VISUAL EXTRAVAGANZA AT A LOCATION NEAR LONDON. AGAIN WE OFFER THE TOP D.J.s FROM THE U.K. AND U.S. ON THREE SEPARATE SYSTEMS.

D.J.s	D.J.s	P.A.s.
CRISS ANGEL – GLASTONBURY	NORMAN JAY – HIGH ON HOPE	CRY SISCO' – AFRODIZZIACT
JUDGE JULES – METHOD AIR	DAVE POCCIONE – U.S.A.	M.C. KINKY –
PHIL PERRY – QUEENS	BOYS IN SHOCK – LONDON	EVERYTHING BEGINS
KID BATCHELOR – CONFUSION	BONES – LIVEWIRE	DIONE –
HARVEY B – FREETOWN	D.J. SOPHI – PROHIBITION	COME GET MY LOVING
CHOCI – FREETOWN	COLIN FAVER – LONDON	DE LITE –
CARL COX – SUNRISE	B.B. BRAD – CHROME	FEATURING OSCAR CHILD
FRANKIE – HIGH ON HOPE	CESARE – SARDINIA	
ROSCOE – SOLARIS	NOEL WATSON	

ATTRACTIONS

SIXTY K TURBO STIMULATION ON THREE SYSTEMS	CUSTOM MADE DANCE PLATFORMS & STAGING
LAZERS AND ANIMATIONS BY DYNAMIC LAZERS	MINDSCAPES THE VISUALS
BEAT GENERATED VIDEO SCREENED ON MEGA VIDEO WALL	GRAPHICS BY i.e. (IMAGE ENGINES)
SKATE BOARDS JUGGLERS	BURGER BAR & BARBEQUE
DANCERS SWEET BAR RIDES	CLOTHES STALL

A TOTALLY LEGAL RAVE FOR BLAST OFF MEMBERS AND GUESTS ONLY.
SOLICITOR, FIREMEN AND MEDICAL OFFICERS IN ATTENDANCE TOGETHER WITH A PROFESSIONAL SECURITY TEAM.
THIS EVENT WILL BE FILMED BY 'ORSAM' IN ASSOCIATION WITH URBAN PRODUCTIONS.
VIDEOS AVAILABLE THROUGH BLAST OFF OUTLETS

TICKET AGENTS

TICKET PRICE £15.00 FROM:
LONDON – BLACK MARKET RECORDS D'ARBLAY ST, W1. TEL: 437 0478
 SOUL II SOUL SHOP 162 CAMDEN HIGH ST, NW1. TEL: 267 3995
 ROB (EAST) TEL: 802 2489 CHARLIE (SOUTH) TEL: 736 8073
SLOUGH – SLOUGH RECORD CENTRE. TEL: 0753 28194
WINDSOR – REVOLUTION RECORDS. TEL: 0753 867221
KENT – JULIE 0479 324904
MANCHESTER – EASTERN BLOC RECORDS AFFLEKS PALACE 35 OLDHAM ROAD. TEL: 061 835 2368
FOR FURTHER INFORMATION CALL THE LOCATION INFORMATION LINE 0836 405421/0
OUR LAST EVENT WAS A HUGE SUCCESS. THIS ONE WILL BE EVEN BETTER. DON'T MISS OUT BOOK EARLY TO AVOID DISAPPOINTMENT. REMEMBER NO TICKET NO ENTRY. DONATIONS TO FRIENDS OF THE EARTH.

BLAST OFF (INTO ORBIT)
// September 1989 // Blast-off promotions in association with Urban Productions
// Near London

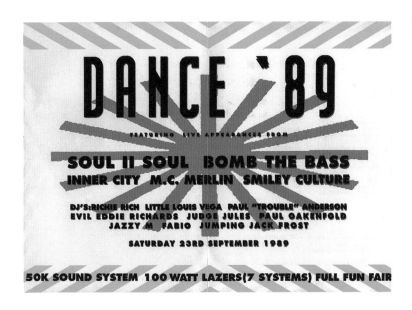

DANCE '89
// September 1989 // Energy presents // In memory of those who died on the *Marchioness*
// Raydon Airfield, Suffolk

THE FABULOUS
FF BROTHERS
PROUDLY PRESENT
ON
SATURDAY 2nd SEPTEMBER

KARMA SUTRA
THE NEXT STEP IN FUN

KARMA SUTRA
// September 1989 // FF Brothers present
// Near Eltham, Surrey

SOUND SELECTORS

Nicky Holloway	Paul Oakenfold	Norman Jay
Johnnie Walker	Fat Tony	Jazzy M.
Gary Dillon	Paul Anderson	Barry C.
Mike Pickering (Hacienda)	Rhythm Doctor	Uncle 22

TICKET AGENTS
BLACK MARKET — BLASS MENSWEAR WELLING, ROMAN RD., ELTHAM
MASH (OXFORD ST.)
BOY — (KINGS RD.)
ALL PREMIER BOX OFFICES
ASTORIA BOX OFFICE
FOR REGIONAL TICKET AGENTS PHONE: 01-851 0689 & 01-986 3704
CREDIT CARD BOOKINGS: 01-240 2245

MEMBERSHIP – TICKET INFORMATION
FOR YOUR LOCAL AGENTS –
DIAL TICKET INFORMATION
01-851 0689 RICHARD
01-312 0671 GERRY
01-312 0254 DARYL AFTER 6PM
0831 403542 ● 0831 403543
DENNY 0831 403581 ● 0831 403546
MAN ABOUT TOWN 0836 326791

PRICE £15 IN ADVANCE ONLY.

P.A.'s, SPECIAL GUESTS AND ATTRACTIONS
FUNFAIR, GYROSCOPE, BUCKING BRONCO,
SPECTACULAR SOUND & LIGHT SHOW
STAY TUNED TO:
CENTREFORCE 88.3FM
and FANTASY 98.6FM
FOR INFO UPDATES
OUR AIM IS TO PLEASE YOU – KARMA SUTRA

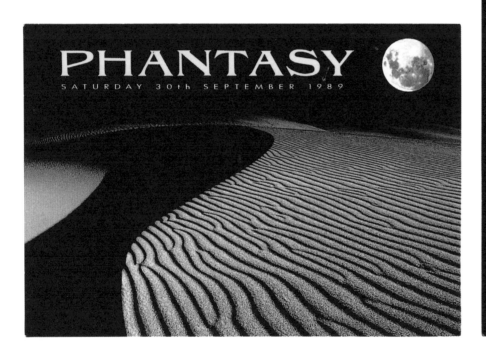

PHANTASY
// September 1989 // Silver Moon Productions
// A venue within the M25

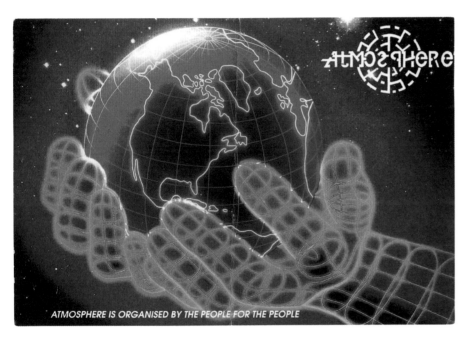

ATMOSPHERE IS ORGANISED BY THE PEOPLE FOR THE PEOPLE

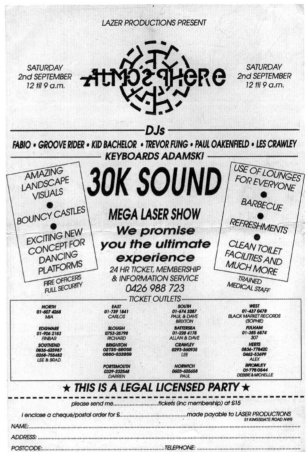

ATMOSPHERE
// September 1989
// Lazer Productions present

HUMANITY

PROMOTIONS

PRESENT

9
September
1989

Humanity

9
September
1989

Cutmasters	Fat Tony	Steve Bicknell	Dem 2
	Fabio	Andy Nicholls	Tony (AJ) and Mark
	Groove Rider	Trevor Fung	Micky Finn

Sound & Lighting — Volume 30k of Turbo Sound
by Entech Sound
20k of Projections, illuminations
& imagers.

Lazers — 30k of watercooled systems.

Construction & Design — by Human Landscapes

Security — by Humanity Promotions.

Live Performances — Adamski Keyboard Wizard
Mr Monday & Ramjack on Percussions

Ticket Outlets
North
Julian 01-903 6267
South
Dave & Paul 01-674 3287
East
Carlos 01-739 1841

South East
Sam 01-703 0628
Wickford
Steve & Jo 0268 764763
Maidenhead
Tim & Fi 0491 576633
Southend
Titus 0702 470635

Black Market Records
01-437 0478
Blue Bird Records
01-287 4757
Mash Oxford Street
01-434 2344
RAP Neal Street
01-240 1319

Tickets including membership £15.00 available through all Ticket Outlets
This event is for Humanity Members and their guests only, No tickets will be available on the door
The management reserves the right to refuse admission
Humanity Dancewear will be available on the night
Mail order available through Steve & Jo on 0268 764763
Beware of forgeries, buy your tickets from official outlets only
All tickets are individually security coded
VIP ticket holders please forward 2 photos before event.

HUMANITY
// September 1989
// Humanity Promotions

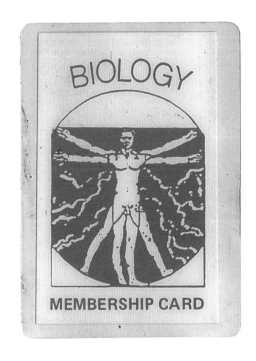

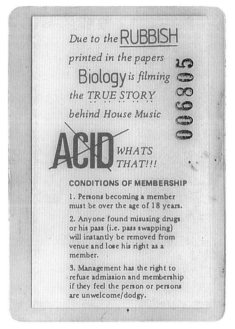

Due to the **RUBBISH**

printed in the papers

Biology *is filming*

the TRUE STORY

behind House Music

~~ACID~~ *WHATS*
THAT!!!

006805

CONDITIONS OF MEMBERSHIP

1. Persons becoming a member must be over the age of 18 years.

2. Anyone found misusing drugs or his pass (i.e. pass swapping) will instantly be removed from venue and lose his right as a member.

3. Management has the right to refuse admission and membership if they feel the person or persons are unwelcome/dodgy.

BIOLOGY
// Circa Mid 1989
// Membership card

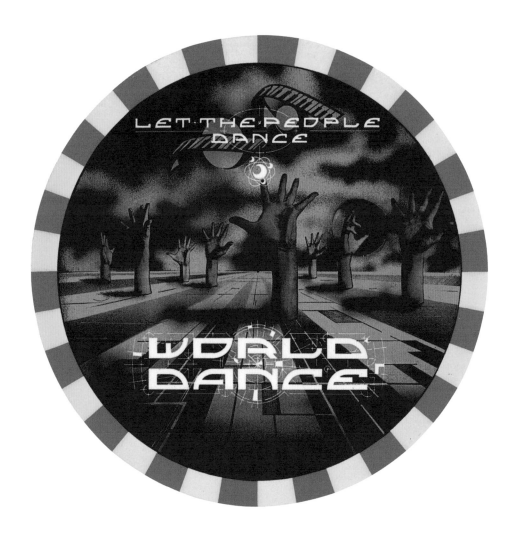

WORLD DANCE 'THE RETURN'
// September 1989 // World Dance Organization
// In a field very near to London

THE
WORLD DANCE ORGANISATION
PRESENTS

30
SEPTEMBER
1989

WORLD DANCE

30
SEPTEMBER
1989

"THE RETURN"
A TRULY INTERNATIONAL DANCE SPECTACULAR FOR CHARITY
10PM - ON SATURDAY 30TH SEPTEMBER 1989 - 9AM
AT A LOCATION VERY NEAR TO LONDON.

ON 19TH AUGUST: "WORLD DANCE WAS TO HAVE BEEN AN **EXTRAORDINARY MOULD BREAKING RAVE**".
THE W.D.O. "TRIED DESPERATELY HARD TO DO IT ALL LEGALLY, BUT WERE BLOCKED AT EVERY TURN BY THE
FORCES OF LAW, WHO REFUSED TO SANCTION A LARGE WELL ORGANISED AND IMAGINATIVE EVENT." "THE
STAGE AND LIGHTING RIGS WERE SET UP IN JUST FOUR HOURS ON SATURDAY EVENING, AFTER THEY HAD MOVED
TO THEIR FIFTH CHOICE VENUE." "THE NIGHT INCLUDED **GREAT LIVE P.A.'S** AND THE SHOW WAS **PRETTY AND
SPECTACULAR** NONETHELESS." "WE WERE LEFT PONDERING ABOUT WHAT MIGHT HAVE BEEN...."? "BUT THE WORLD
DANCE CREW PROMISE THEY'LL BE BACK FOR MORE....!" TIME OUT AUG 30 - SEPT 8 1989.

INFORMATION

THE ORGANISATION RETURNS WITH THE FULL SHOW TO BE HELD IN AN AMAZING NEW INDOOR VENUE. AT THE EVENT THERE WILL
BE: (SEEN FOR IST TIME IN THE U.K.) THE LARGEST EVER "PURPOSE BUILT - MULTI LEVEL" DANCE ARENA PLUS THE INCREDIBLE
VIDEO WALL. MUSIC IS THE ONE TRULY INTERNATIONAL LANGUAGE, THUS SINCE TIME BEGAN MAN HAS CREATED MUSIC AND DANCE
FOR HIS PLEASURE: IT IS NOT A CRIME NOR AN OFFENCE WE SAY "LET THE PEOPLE DANCE"!

THE DECK TECHNICIANS. FABIO. PAUL "TROUBLE" ANDERSON. JUDGE JULES. FAT TONY. KID BATCHELOR. CARL COX. MICK FINN.
GROOVE RIDER. ROY THE ROACH, COLIN HUDD. PLUS OTHERS YET TO BE CONFIRMED.
LIVE PERFORMANCES. THE FIRST EVER U.K. APPEARANCE BY SIDNEY YOUNGBLOOD - "IF ONLY I COULD". THE AMAZING ADAMSKI -
KEYBOARD WIZARD. THE J.B.'S - JAMES BROWNS HORN SECTION. M.C. KINKY AND THE EZEE POSSEE - "EVERYTHING STARTS" LISA M - "ROCK
TO THE BEAT/GOING BACK TO MY ROOTS." MR MONDAY AND RAMJACK - POWER PERCUSSION.
ADVIDO -THE ULTIMATE PAN AFRICAN DANCE TROUPE.

TICKETS AND INFORMATION CENTRES

BLACK MARKET RECORDS - 25 D'ARBLAY ST. SOHO, W1. 437 0478. QUAFFS RECORDS - CNR PORTOBELLO & LANCASTER ROAD, W11. 792 0068. VINYL ZONE - 112 NEW KINGS
ROAD, SW6. 384 2320. RAP - 60 NEAL STREET, COVENT GARDEN, WC2. 240 1319. MASH/PASSION RECORDS - 73 OXFORD STREET. 434 2344. CITY SOUNDS - HIGH HOLBORN, WC1.
405 5454. BLUEBIRD RECORDS - BERWICK STREET, SOHO. 287 4757 / EDGEWARE ROAD. 723 9090/HIGH ROAD STREATHAM. 677 1887. MUSIC POWER - GREEN LANES,
HARRINGEY, N4. 800 6113 / CENTRE WAY, ILFORD. 478 2080. THE ASTORIA - BOX OFFICE. 434 0403 PLUS ALL PREMIER BOX OFFICES. SCREEN - 97-99 STREATHAM HIGH
ROAD, SW16. 677 0591/37 HIGH STREET,. EALING W5. 566 1855

LONDON	REGIONAL
SOUTH - DAVID & PAUL - 674 3287	SOUTHEND - DAVID 0702 470635
NORTH - JULIAN - 903 6267	COLCHESTER - LES - 0206 762123
EAST - CARLOS - 739 1841	SLOUGH - STUART - 0836 556843
SOUTH EAST - MICKY - 469 3119	MAIDENHEAD - TIM & FI - 0491 576633
BATTERSEA - ALLAN & DAVE - 228 4178	WATFORD - STEVE & GARY - 0836 548504
FULHAM CHELSEA - NATALIE - 373 0276	BRIGHTON - MAXINE - 0273 27857
SOUTHWARK - SAM - 703 0928	PORTSMOUTH - DARREN - 0329 232548
TOTTENHAM - MICHAEL -808 0540	NORWICH - PAUL - 0603 625658
EDGEWARD - FINN/BAR - 906 2183	MANCHESTER - SPINN INN - 061 834 5383
CRAWLEY - LEE - 0293 560935	MARGATE - MARK - 0843 296856
ROMFORD & AREAS - IAN - 04022 25170	BATH, BRISTOL & THE WEST COUNTRY -
	DREAMTIME PR - 0860 448919

MAKE A DATE FOR THE WORLD DANCE HALLOWEEN PARTY SAT 28TH OCTOBER 1989.
THIS EVENT IS BEING STAGED IN CONJUNCTION AND WITH THE FULL SUPPORT OF
C.A.R.E. A CHILDRENS CHARITY.
.TICKETS ARE STRICTLY NOT AVAILABLE AT THE DOOR. THIS IS A
PRIVATE PARTY FOR WORLD DANCE MEMBERS ONLY. THE ORGANISATION
RESERVES THE RIGHT TO REFUSE ADMISSION. THIS
EVENT IS BEING PROMOTED ALL OVER EUROPE,

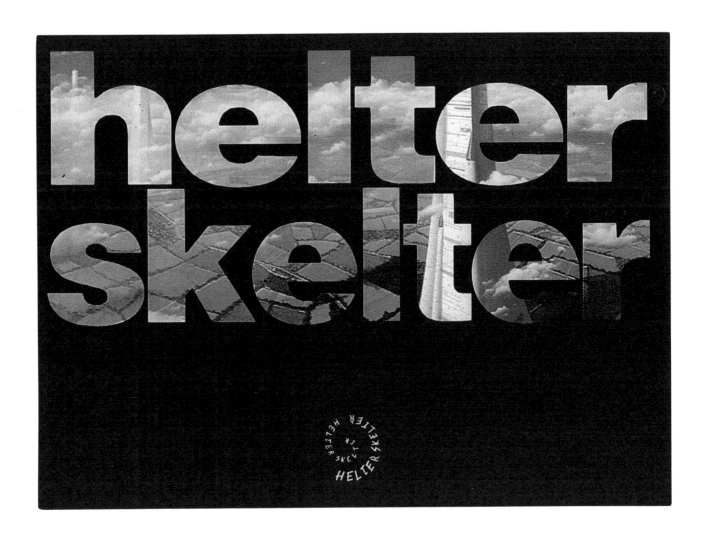

HELTER SKELTER
// September 1989 // Outer Limits & Pumphouse Productions
// Banbury, Oxfordshire

"OUTER LIMITS" "NEW WORLD" PUMPHOUSE PRODUCTIONS"

proudly present

THE GREATEST DANCE MUSIC SPECTACULAR EVER APPEARING FOR ONE NIGHT ONLY ON

30th SEPTEMBER 1989

AT THE

HELTER SKELTER

DANCE MUSIC FESTIVAL

Featuring from the USA

- **CE CE ROGERS** performing Someday, Forever
- **KLF** performing 3am, What Time Is Love
- **KARIYA** performing Let Me Love You For Tonight
- **LIL LOUIS** performing French Kiss
- **LOLLETTA HOLLOWAY (Black Box)** performing Ride On Time, Love Sensation
- **TWO IN A ROOM** performing Everybody In The House Say Yeah
- **JOMANDA** performing Make My Body Rock
- **THE MINUTEMEN** performing OK Alright, Bingo Bongo

- **SHA LOR** performing I'm In Love
- **CORPORATION OF ONE** performing The Real Life
- **BAS NOIR** performing My Love Is Magic, I'm Glad You Came To Me
- **RALPH ROSARIO** performing I Want Your Love

And from the UK

- **PAUL RUTHERFORD** performing Oh World
- **JOLLY ROGER** performing Why Can't We Live Together
- + SPECIAL GUESTS

DJ/PRODUCERS TO COMPLIMENT MARK MOORE, EDDIE RICHARDS, KID BATCHELOR, JAZZY M, FRANKIE BONES, ROMAN RICARDO, FREDDY BASTONE, NORTY COTTO, MICKY 'HOT MIX 5' OLIVER.

Artiste and Music Programming by Vito Bruno, Tim Taylor & Colin Davie.

★ FULL CONTINENTAL THEME PARK ★ INTERNATIONAL CRAFT FAIR ★ ZOOM RECORD MARKET ★ THAI BARBECUE ★ CHILLOUT CAFE ★ NUMEROUS SIDE SHOWS AND STALLS ★ SUPERIOR QUALITY TURBOSOUND SYSTEM ★ MULTI-COLOURED LASERS ★ FREE CAR PARK ★ MEDICAL STAFF IN ATTENDANCE ★ HEATED COVERED SITE ★ LICENCED AND LEGAL

BLACK MARKET 25 D'Arblay St, W1. RED RECORDS 47 Beak St W1, Tel 01-274 4476, 500 Brixton Rd, SW9, Tel 01-734 2746 ODDBALLS 136 Hoxton St N1, Tel 01-739 3698 VINYL ZONE 112 New Kings Rd W2, Tel 01-384 2320 SOUL II SOUL The Basement 162 Camden High St NW1, Tel 01-267 3995 MUSIC POWER 37 Grand Parade Green Lane N4, Tel 01-800 6113 TRUMP RECORDS 188 High St Ruislip, Tel 0895 635507 RECORD VILLAGE 256 Hoe St E17, Tel 01-520 7331 G + M RECORDS 302 Elephant & Castle Shopping Centre SE1, Tel 01-708 0988 REVOLUTION RECORDS (Slough) 7 St Leonards Rd, Tel 0753 867221 CRASH MUSIC CO (Leeds) 35 The Headrow, Tel 0532 465823/0532 436743 PINK MOON Acorn Gallery Newington, Tel 051-709 4819 LOADING BAY RECORDS (Birmingham) 586 Bristol Rd, Tel 021 472 2463, Mail Order – Tel 0612 362555/2577, PICADILLY RECORDS (Manchester) Tel 0612 362555/2577 DREAMTIME PROMOTIONS (Bath Bristol & West Country), Tel 0860 448919 VICTORIA TICKETS (All Areas), Tel 01-828 0084 FINBAR (Edgware) Tel 01-906 2183 KEVIN (Reading) Tel 0734 782953 MAXINE (Brighton) Tel 0273 27857 JO (Milton Keynes) Tel 0908 314746 BRENDON (Luton) Tel 0582 422534 KEITH (Maidenhead) Tel 062 8825538 GARY (Essex) Tel 0621 857677 JOE (Feltham) Tel 0831 490 730 CHALKY (Banbury) Tel 0295 271190 TRACE (Portsmouth) Tel 0892 545203 GEOFF (St Neots) Tel 0480 212196 FLIP (Essex) Tel 0402 754806

No membership or tickets on sale after 28th Sept. Discount on tickets before Friday 22nd September

This event is a private party for Helter Skelter members and their guests only, membership and tickets are available solely from appointed agents. Beware of forgeries. Over 18's only.

RETURN RAVE

THURSDAY 22nd SEPT

ELECTRIC BALLROOM

CAMDEN TOWN N.W.1

9-2AM £4 or £2 with
special card

YOU KNOW THE DJ LINE UP
YOU KNOW THE MUSIC POLICY
JUST DANCE WICKED

DANCE WICKED
// September 1989 // 'Return Rave'
// Electric Ballroom, Camden Town, London NW1

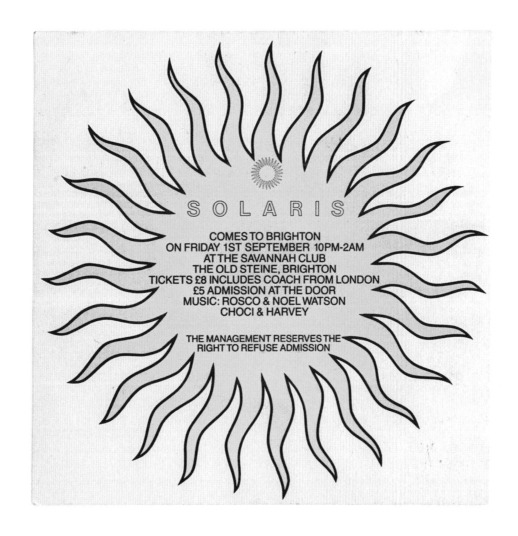

SOLARIS

COMES TO BRIGHTON
ON FRIDAY 1ST SEPTEMBER 10PM-2AM
AT THE SAVANNAH CLUB
THE OLD STEINE, BRIGHTON
TICKETS £8 INCLUDES COACH FROM LONDON
£5 ADMISSION AT THE DOOR
MUSIC: ROSCO & NOEL WATSON
CHOCI & HARVEY

THE MANAGEMENT RESERVES THE
RIGHT TO REFUSE ADMISSION

SOLARIS
// September 1989 // Nick Coleman presents
// The Savannah Club, The Old Steine, Brighton

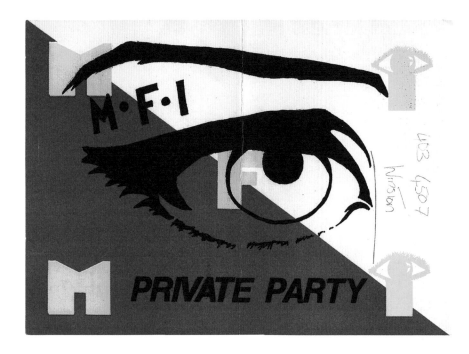

Two forces have come together to be as one — HORIZON AND MAD FOR IT
(for a private party)

 Saturday 2nd September 1989

Music Makers

PAUL OAKENFIELD PAUL TROUBLE ANDERSON J.C.
EVIL EDDIE LINDON C. DEM 2
NICKY HOLLOWAY JONH JULES CLEVELAND A.
VICKI EDWARDS TULLY DJ STUMPY

+ GUEST DJ's ON THE NIGHT

Entertainment

Live P.A.s — 30k Sound System — For the first time The Light Fantastic — Richie Rich —
Jazz and the Brothers — MC Daddy Chester, Our very own Keyboard Wizard — Full Fun
Fair — Hot & Cold Food — Candy Store — Free Gifts — Being Videoed for future showing —
Bouncy Castle — VIP lounge

For the People

There will be fully trained medical staff on site, with complete hygiene facilities for good
girls and boys.

Official Ticket Outlets and Agents

LONDON
BLUE BIRDS, Soho — 01-494 1081
Edgware Road, W2 — 01-723 9090
RED RECORDS, Brixton — 01-274 4476
Soho — 01-734 2746
BLACK MARKET RECORDS — 01-437 0478
MUSIC POWER — Haringey — 01-800 6113
 Ilford — 01-478 2080
Louis Menswear, Islington — 01-837 0005
Clive, Palmers Green — 01-881 5726
Danielle, Victoria — 01-828 0084
Pauline, Chigwell — 01-501 3609
Jane, East London — 01-476 5613
GET FRESH RECORDS — 01-969 3188
Les — 0836-764764
Julian — 01-903 6267
Hot Line — 0898-662700
 0836-537135

REGIONAL
Carlos, Slough — 97-71940
Swanny, Luton — 0582-405657
Watford — 0836-548504
Past & Present, Watford — 0923-32772
Classical Rock, Harpenden — 05827-64475
Maidstone, Michelle — 0892-834887
Sam, Southend — 0702-430294
Essex, Darren — 0268-759086
Cliff, Luton — 0836-540685
Rick — Portsmouth 0705-811541 after 6pm
Watford — 0836-285534
Page 01-840 7000 — 0788707 / 0880662 / 0721209

HOTLINE Nos & COACH INFO
Trix — 0836-378230
The Doc — 0836-764317 / 0831-401202/3

BIRMINGHAM
Summit Records — 021-643789

These are official Ticket Agents — beware of forgeries! This Party is **LEGAL & SAFE.** We
guarantee Venue, DJ's (just ask them) and money back (less 10%) should our Party not
take place. No towing or clamps, on-site parking.
**This is a private party for members and direct agents only — no tickets
whatsoever will be sold on site.**
DRESS: Like a psychedelic war flower.
VENUE: To fulfil your dreams — with no dangerous chemicals!
All MFI tickets for Saturday 19th August are valid for this Party.
Thanks for waiting — Sorry — MFI.

MAD FOR IT
// September 1989 // Horizon and Mad For It promotions
// Near Northampton

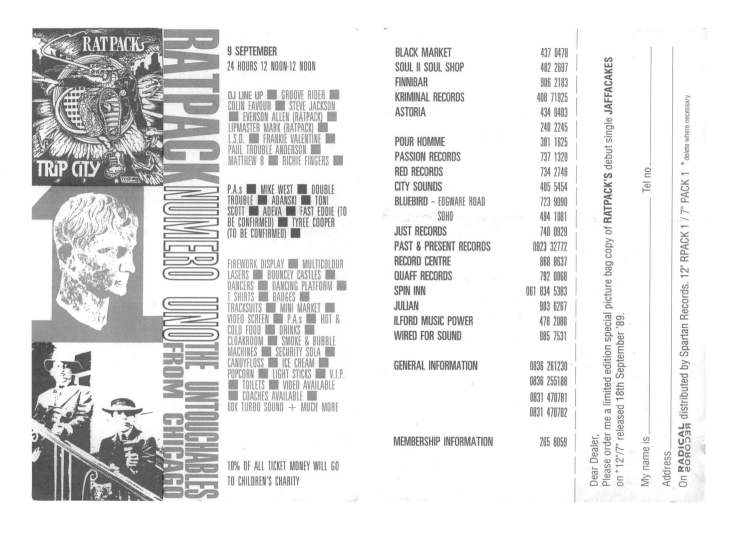

RATPACK NUMERO UNO

THE UNTOUCHABLES FROM CHICAGO

9 SEPTEMBER

24 HOURS 12 NOON-12 NOON

DJ LINE UP ■ GROOVE RIDER ■
COLIN FAVOUR ■ STEVE JACKSON
■ EVENSON ALLEN (RATPACK) ■
LIPMASTER MARK (RATPACK) ■
L.S.D. ■ FRANKIE VALENTINE ■
PAUL TROUBLE ANDERSON ■
MATTHEW B ■ RICHIE FINGERS ■

P.A.s ■ MIKE WEST ■ DOUBLE
TROUBLE ■ ADANSKI ■ TONI
SCOTT ■ ADEVA ■ FAST EDDIE (TO
BE CONFIRMED) ■ TYREE COOPER
(TO BE CONFIRMED) ■

FIREWORK DISPLAY ■ MULTICOLOUR
LASERS ■ BOUNCEY CASTLES ■
DANCERS ■ DANCING PLATFORM ■
T SHIRTS ■ BADGES ■
TRACKSUITS ■ MINI MARKET ■
VIDEO SCREEN ■ P.A.s ■ HOT &
COLD FOOD ■ DRINKS ■
CLOAKROOM ■ SMOKE & BUBBLE
MACHINES ■ SECURITY SOLA ■
CANDYFLOSS ■ ICE CREAM ■
POPCORN ■ LIGHT STICKS ■ V.I.P.
■ TOILETS ■ VIDEO AVAILABLE
■ COACHES AVAILABLE ■
60K TURBO SOUND + MUCH MORE

10% OF ALL TICKET MONEY WILL GO
TO CHILDREN'S CHARITY

BLACK MARKET	437 0478
SOUL II SOUL SHOP	482 2697
FINNIBAR	906 2183
KRIMINAL RECORDS	408 71925
ASTORIA	434 0403
	240 2245
POUR HOMME	301 1625
PASSION RECORDS	737 1320
RED RECORDS	734 2746
CITY SOUNDS	405 5454
BLUEBIRD – EDGWARE ROAD	723 9090
SOHO	494 1081
JUST RECORDS	740 0929
PAST & PRESENT RECORDS	0923 32772
RECORD CENTRE	868 8637
QUAFF RECORDS	792 0068
SPIN INN	061 834 5383
JULIAN	903 6267
ILFORD MUSIC POWER	478 2080
WIRED FOR SOUND	985 7531
GENERAL INFORMATION	0836 261230
	0836 255188
	0831 470781
	0831 470782
MEMBERSHIP INFORMATION	265 8059

Please order me a limited edition special picture bag copy of **RATPACK'S** debut single **JAFFACAKES**

on *12"/7" released 18th September '89.

Dear Dealer,

My name is _____

Address _____

Tel no _____

On **RADICAL RECORDS** distributed by Spartan Records. 12" RPACK 1 / 7" PACK 1 * delete where necessary.

TRIP CITY / NUMERO UNO
// September 1989
// A joint venture including 'The Untouchables', Elephant and Castle, London, SE11

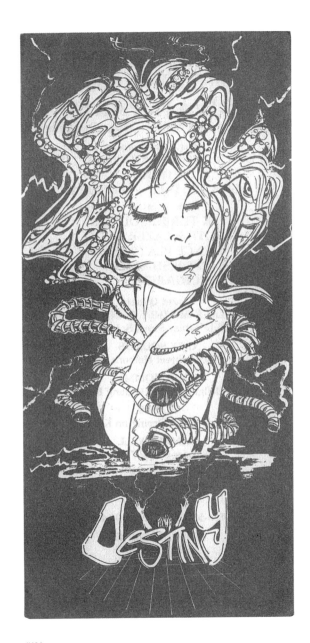

DESTINY DANCE FESTIVAL '89
PRIVATE PARTY
Saturday 23rd Sept **11pm Onwards**

D.J.s including
★J.D.Y. ★GROOVE RIDER ★D.J. SLY
★FABIO
+SPECIAL D.J.s + LIVE P.A.

★ ★ ★ ★

15K TURBO SOUNDS
LIGHT & LAZER SHOW
DANCE PLATFORMS
REFRESHMENTS
CIGARETTES

Ticket Outlets
BLACK MARKET RECORDS
25 D'Arbiay Street Soho W1

CITY SOUNDS
Procter Street Holborn W1

POUR HOMME
71 Bellgrove Road Welling Kent

ELPEES
High Street Orpington Kent

CAMBERWELL
Roger 01-737 7375

RAINHAM
Rhonda 0402-756597

BROMLEY
Phil 0836-564430 Nick 01-460 6428

INFO HOTLINE
Mick 0836-332079

PHIL 0836-564430

STRICTLY 18 & OVER ONLY
ADMISSION TICKET HOLDERS ONLY

DESTINY DANCE FESTIVAL
// September 1989
// Kent

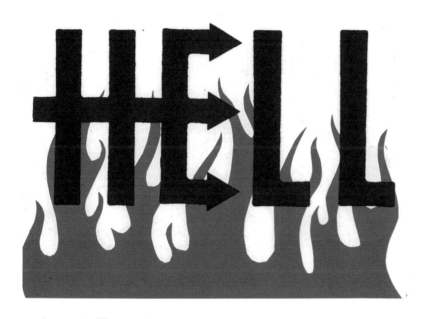

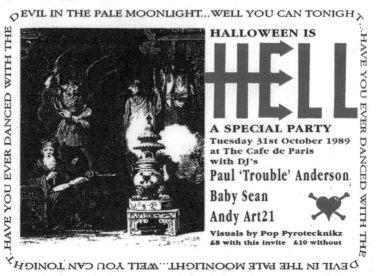

HELL
// October 1989 // Halloween party
// Café de Paris, Leicester Square, London WC2

KIMOTA
// October 1989 // From Solaris and Nick Coleman
// Grays Inn Road, London WC1

FROM SOLARIS

KIMOTA

RETURNS

ON SATURDAY 14th OCTOBER 11 PM ONWARDS
MUSIC BY CHOCI, ROSCO, CARL COX, PETE HELLER, JUDGE JULES, NORMAN JAY
ADVANCE TICKETS ONLY FROM SOLARIS, 4 GRAYS INN ROAD SUNDAYS,
BOND 10 NEWBURGH ST 437 0071
CLUB MFI 68 BERWICK ST 734 6620
QUAFF RECORDS, 61 LANCASTER RD W11 792 0068

THE MANAGEMENT RESERVES THE RIGHT TO REFUSE ADMISSION

bingobangobongo

DANCE FURY

BPM Productions
Present

bingobangobongo II

Saturday October 28th 11 till 11

(from the people who brought you *bingobangobongo I*)
at an exclusive London Venue

With special guest DJ from New York

FRANKIE KNUCKLES

featuring Adamski (*Keyboard Wizard*) and MC Daddy Jeaster

Plus

TURNTABLE DICTATORS

◉ PAUL ANDERSON ◉ EVIL EDDIE RICHARDS ◉
◉ IAN ROBINSON ◉ CARL COX (3 Deck Mixing) ◉

ATTRACTIONS

(30K) OF TURBO NOISE. LIGHTS. ILLUMINATIONS. 30 X 50FT VIDEO SCREEN FEATURING LIVE AUDIENCE.
PROJECTORS AND FILM STRIPS. SPECIAL EXCLUSIVE VIP LOUNGE WITH BAR. COURT JESTERS.

TICKET AGENTS

ADAM - 349 3345 (Edgeware)
PAUL - 505 6751 (Woodford)
JAFFA - 0553 88294 (KynsLyn)
RICHARD - 953 2745 (Borehamwood)
MARK - 0553.3771538 (Kynslyn)

WARREN - 0908 316006 (Milton Keynes)
SARAH/JADE - 0836 636193 (Fulham)
NICK - 0831 446138 (Herts/Cheshunt)
MARK - 0831 446137 (Finchely)
WINSTON - 868 4519 (Wembley)

TICKET OUTLETS

BLACK MARKET RECORDS
25 D'ARBLY ST SOHO. LONDON W1
01 437 0478

PASSION (MASH)
OXFORD ST. LONDON W1
01 434 2344

RED RECORDS
47 BEAK ST SOHO. LONDON W1
01 734 2746

RED RECORDS
(BRIXTON)
01 274 4476

TICKETS £20 INCLUDING MEMBERSHIP
All Tickets **MUST** be purchased in ADVANCE. No Tickets will be available on the day.
Strictly Invitation only. This is a private party for VIPS, friends and
associates of **BPM** Productions.

24hr INFORMATION HOTLINE : 704 0170 (from October 15th)

BINGOBANGOBONGO II
// October 1989 // BPM Productions
// Central London venue

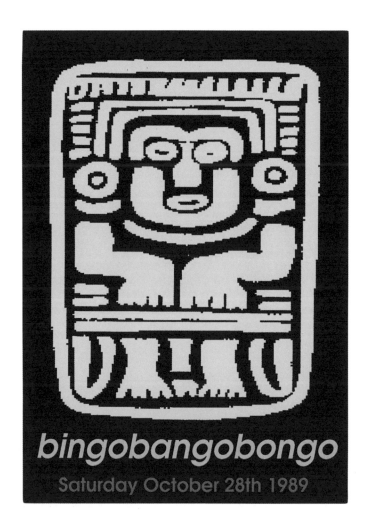

bingobangobongo
Saturday October 28th 1989

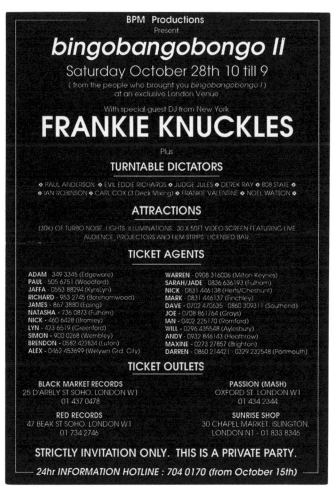

BPM Productions
Present

bingobangobongo II

Saturday October 28th 10 till 9

(from the people who brought you *bingobangobongo I*)
at an exclusive London Venue

With special guest DJ from New York

FRANKIE KNUCKLES

Plus

TURNTABLE DICTATORS

◆ PAUL ANDERSON ◆ EVIL EDDIE RICHARDS ◆ JUDGE JULES ◆ DEREK RAY ◆ 808 STATE ◆
◆ IAN ROBINSON ◆ CARL COX (3 Deck Mixing) ◆ FRANKIE VALENTINE ◆ NOEL WATSON ◆

ATTRACTIONS

(30K) OF TURBO NOISE, LIGHTS, ILLUMINATIONS. 30 X 50FT VIDEO SCREEN FEATURING LIVE
AUDIENCE, PROJECTORS AND FILM STRIPS, LICENSED BAR.

TICKET AGENTS

ADAM - 349 3345 (Edgeware)
PAUL - 505 6751 (Woodford)
JAFFA - 0553 88294 (KynsLyn)
RICHARD - 953 2745 (Borehamwood)
JAMES - 867 3880 (Ealing)
NATASHA - 736 0873 (Fulham)
NICK - 460 6428 (Bromley)
LYN - 423 6519 (Greenford)
SIMON - 900 0268 (Wembley)
BRENDON - 0582 422834 (Luton)
ALEX - 0462 453699 (Welwyn Grd. City)

WARREN - 0908 316006 (Milton Keynes)
SARAH/JADE - 0836 636193 (Fulham)
NICK - 0831 446138 (Herts/Cheshunt)
MARK - 0831 446137 (Finchley)
DAVE - 0702 470635 - 0860 309311 (Southend)
JOE - 0708 861764 (Grays)
IAN - 0402 225170 (Romford)
WILL - 0296 435548 (Aylesbury)
ANDY - 0932 846143 (Heathrow)
MAXINE - 0273 27857 (Brighton)
DARREN - 0860 214421 - 0329 232548 (Portmouth)

TICKET OUTLETS

BLACK MARKET RECORDS
25 D'ARBLY ST SOHO. LONDON W1
01 437 0478

PASSION (MASH)
OXFORD ST. LONDON W1
01 434 2344

RED RECORDS
47 BEAK ST SOHO. LONDON W1
01 734 2746

SUNRISE SHOP
30 CHAPEL MARKET, ISLINGTON,
LONDON N1 - 01 833 8346

STRICTLY INVITATION ONLY. THIS IS A PRIVATE PARTY.

24hr INFORMATION HOTLINE : 704 0170 (from October 15th)

THE LEVEL RISES

UNDERWATER

OPENING NIGHT 18th OCTOBER
EVERY WEDNESDAY 10pm-3.30am
AT 201 WARDOUR ST., LONDON W.1.
SPECIALIZING IN THE EVOLUTION OF EUROPEAN & AMERICAN HOUSE MUSIC
£7 ADMISSION WITH THIS INVITATION

RIGHTS OF ADMISSION ARE RESERVED BY THE MANAGEMENT.

UNDERWATER
// October 1989 // Nick Coleman presents // Opening night party
// Wardour Street, London W1

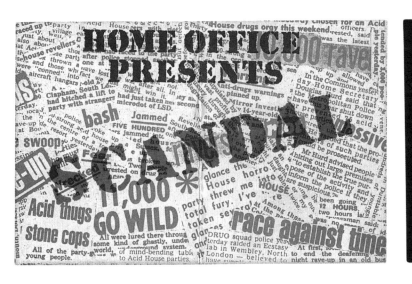

SCANDAL
// October 1989 // Home Office presents
// Central London

HOME OFFICE
SAT. 28 OCT '89
MUSIC-MR.C » KID BATCHELOR »
EDDIE RICHARDS » COLIN FAVER
FEMI B » DAD » LAGGY. LIGHTING
SUBTLE. SOUND IMMACULATE
£12 INC. MEMBERSHIP. TICKET
AGENTS-VINYL ZONE 112 NEW
KING'S RD. SW6. 384 2320---
BLACK MARKET 25 D'ARBLAY»»»
ST. W1. 347 0478. BLUEBIRD »
376 EDGEWARE RD. 723 9090!!
FOR MORE INFO: 0860 435457
01-281 9676 ········· 01-558 1263

THE ONE
// October 1989 // Underground Image presents
// Central London

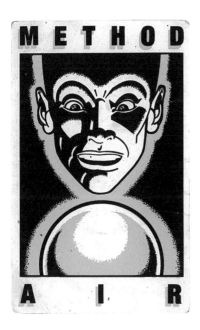

METHOD AIR
// October 1989
// The Arch, Goding Street, London SE1

HELL
// November 1989
// The Fridge, Brixton, London SW2

SUPERSTITION

11 & 25 NOVEMBER 1989
10PM — 3.30AM

MAIN ROOM:

C J MACKINTOSH

ROOM 2:

THE INVISIBLE MAN
DJ MAZ & GUESTS

CHEAP BAR
FORTUNE TELLER
ADMISSION £7

THORNHAUGH ST
OFF RUSSELL SQ WC1

LIVE MUSIC
FREE CAR PARK
JUICE FROM 1AM

SUPERSTITION
// November 1989 // Dave Dorrell presents
// Thornhaugh Street, London WC1

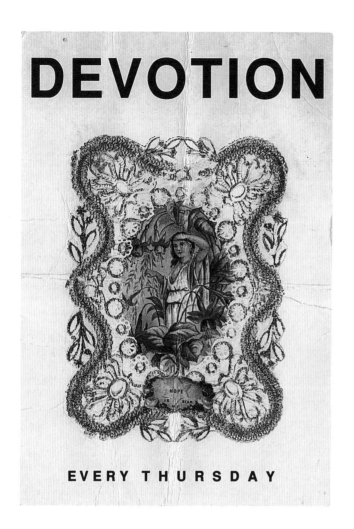

DEVOTION

EVERY THURSDAY

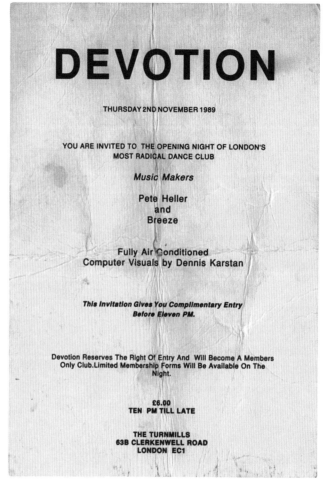

DEVOTION

THURSDAY 2ND NOVEMBER 1989

YOU ARE INVITED TO THE OPENING NIGHT OF LONDON'S
MOST RADICAL DANCE CLUB

Music Makers

Pete Heller
and
Breeze

Fully Air Conditioned
Computer Visuals by Dennis Karstan

*This Invitation Gives You Complimentary Entry
Before Eleven PM.*

Devotion Reserves The Right Of Entry And Will Become A Members
Only Club. Limited Membership Forms Will Be Available On The
Night.

£6.00
TEN PM TILL LATE

THE TURNMILLS
63B CLERKENWELL ROAD
LONDON EC1

DEVOTION
// November 1989 // Opening night party complimentary invite
// The Turnmills, Clerkenwell Road, London EC1

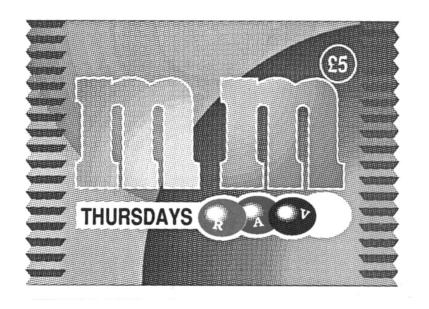

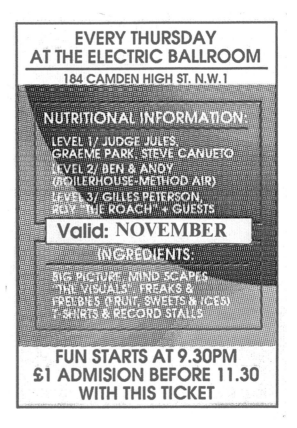

**EVERY THURSDAY
AT THE ELECTRIC BALLROOM**

184 CAMDEN HIGH ST. N.W.1

NUTRITIONAL INFORMATION:

LEVEL 1/ JUDGE JULES,
GRAEME PARK, STEVE CANUETO
LEVEL 2/ BEN & ANDY
(BOILERHOUSE-METHOD AIR)
LEVEL 3/ GILLES PETERSON,
ROY "THE ROACH" + GUESTS

Valid: NOVEMBER

INGREDIENTS:

BIG PICTURE, MIND SCAPES
'THE VISUALS' FREAKS &
FREEBIES (FRUIT, SWEETS & ICES)
T-SHIRTS & RECORD STALLS

**FUN STARTS AT 9.30PM
£1 ADMISION BEFORE 11.30
WITH THIS TICKET**

MM
// November 1989 // Manasseh promotions
// Electric Ballroom, Camden Town, London NW1

RUSH PRODUCTIONS PRESENT

'SATISFACTION'

THIS IS AN INSIDE VENUE 12 'TIL LATE
ON SATURDAY 11th NOVEMBER 1989

Deck Technicians
Fabio ★ Egor ★ Frankly Dancing D
Jumping Jack Frost ★ Chris Angel
Groove Rider ★ Kid Batchelor ★ Fat Tony
Zoo Experience ★ Steve Bicknell
Top DJ's From U.S.A.
★50K of Sound★

Smoke Machines ★ Wind Machines
Bubble Machines ★ Lasers ★ Visions
Video Wall ★ Chill Out Lounge ★ Bouncy Castles

★ Free Ice Poles & Ice creams from 2-3 am ★
Hamburgers ★ Hot Dogs ★ Coffee
Ice Cold Drinks ★ Fruit Bar ★ Candy Floss

TICKETS MUST BE PURCHASED IN ADVANCE
NO TICKETS WILL BE AVAILABLE ON THE DAY
THIS IS A PRIVATE PARTY FOR RUSH MEMBERS
AND FRIENDS ONLY

★ TICKET OUTLETS ★

Finbar, Edgware 906-2183
Jock Stocks, Fulham 741-0544 Dave, South-London 0860-473 627
Julian, Wembley 908 6506 Charlie, North-London 0860-473 628

SATISFACTION
// November 1989 / Rush Productions present
// Central London

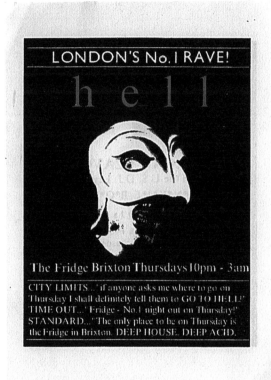

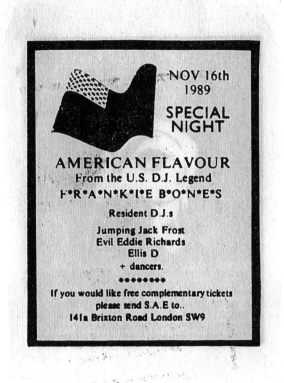

HELL
// November 1989 // American Flavour
// The Fridge, Brixton, London SW2

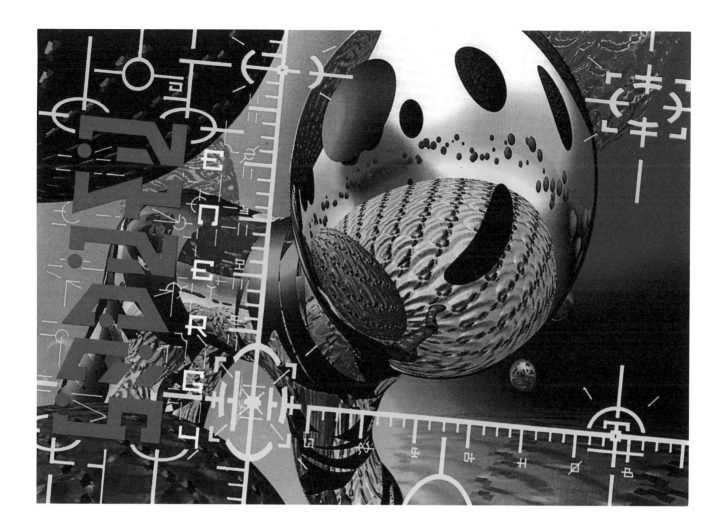

ENERGY
// November 1989 // Karma Productions
// Film Studios, London

PHOENIX PRODUCTIONS PRESENT

—LIFE LINE—
SATURDAY 9TH DECEMBER 1989
THE ULTIMATE VOYAGE

*The haunting melody of Acid House has enchanted the
minds of millions worldwide and has returned after
a summer of bad publicity*

PHOENIX PRODUCTIONS PRESENT TO YOU — THE RAVER

—LIFE LINE—
THIS ONES FOR THE HISTORY BOOKS

*We aim to satisfy your every wish, top Guest P.A.'s,
The best in vinyl wizardry, 50k Rig, light and lazer fantastic
We want to bring back the joy and happiness
that raves used to have*

REMEMBER US – LIFELINE

—————— *MUSIC & DJ LINE UP* ——————

SUDDEN IMPACT	RYTHM DOCTOR	ENCHANTRESS
FLEX	FREE STYLE FLIP CORPORATION	HYPE
DESTINY	BUSY B	ODYSEY
HAVOC	RAT-PAK	MANIA II
M.C. DET	BLAZE	IMAGE

OFFICIAL TICKET AGENTS
WIRED FOR SOUND, Mare Street, Hackney. 01-985 7531
BLACK MARKET RECORDS, D'Arblay Street, Soho 01-437 0478
MR MUSIC, Kingsland High Street, Hackney 01-254 4503
MUSIC POWER, Centerway, Ilford 01-478 2080 & Grand Parade, N4 01-800 6113
BLUE BIRD RECORDS, 12 Berwick Street, Soho 494 1080
GROOVE RECORDS 52 Greek Street, Soho 01-437 4711
MR BAGEL BAKERY, 87 Reighton Road, Clapton, E5 01-806 4047 24hrs

We assure you that Phoenix Productions has covered all possible legal areas

TICKETS MUST BE PURCHASED IN ADVANCE.
NO TICKETS AVAILABLE ON THE NIGHT.
THIS IS A PRIVATE PARTY BY INVITATION ONLY

STATEMENT
*ACID MUSIC: A STATEMENT UNDERSTOOD BY MANY FOR IT'S
TRUE REASON AND JUST ACKNOWLEDGED BY OTHERS FOR IT'S
CURRENT MEANING*

PHEONIX PRODUCTIONS MEMBERSHIP & INFORMATION
Telephones 0831 124941 and 0831 124963

LET THE PEOPLE DANCE!
THE MANAGEMENT RESERVE THE RIGHT TO ALTER THE ABOVE INFORMATION

— LIFE LINE —
// December 1989
// Phoenix Productions present 'The Ultimate Voyage'

THANKS GIVING PARTY
// December 1989 // Orpheus presents
// The Fridge, Brixton, London SW2

DEEP UNDERGROUND SOUNDZ NEW BEAT GARAGE TECHNO

SATURDAY 16th DEC 1989
MEETING POINT
GOODSWAY (KINGS X
MOBIL PETROL STATION)

PARK YOUR CARS SENSIBLY
*THE MANAGEMENT HAVE THE
RIGHT TO REFUSE ENTRY*
STRICTLY OVER 18s

D. J. STATIC - IBIZA
DEM 2 - IBIZA
MIKE WEST - IBIZA
PLUS GUEST KINNIE KEN
DANCE FM
MAX AXE SUN RADIO
MEMBERS ONLY NEW VENUES
LIGHT, SWEETS, LOVE LOUNGE, WC
100 % LEGAL & SAFE

FOR FURTHER INFORMATION LISTEN TO SUNRISE AND DANCE FM RADIO
HOT LINE No. STARTS FRIDAY/SATURDAY TEL: 0860-245302

THE FANTASTIC IBIZA
// December 1989
// Meeting point Goodsway, King's Cross NW1

WE NOW BRING YOU

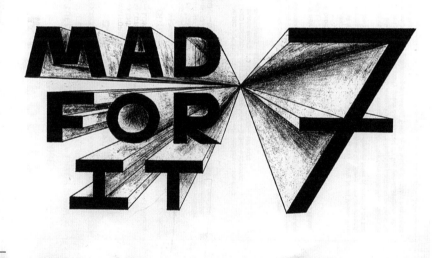

MAD FOR IT 7
// December 1989
// Mad For It promotions

M A D F O R I T !
16th DECEMBER, 1989

★ 30K TURBO SOUND ★ LIGHT SHOW ★ LAZER SHOW ★
★ VIDEO RECORDING ★ SECURITY ★

XX

DJ's FROM ALL REGIONS

MILES — WATFORD	FABIO — RAGE
MARKIE — KENT	TULLY — LONDON
SWAN 'E' — LUTON	STEVE GURLEY — SOUTH OF ENGLAND
ALISTAIR — LONDON	JUMPIN JACK FROST LIGHTING FM — LONDON

—— OUTLETS —— TICKETS —— AGENTS ——

REGIONAL　　　　　　　　　　　**LONDON**

SWANNY — 0582-405-657 — LUTON	PAULINE — 501-3609 — CHIGWELL
MICHELLE — 0892-834-887 — MAIDSTONE	JANE — 476-5613 — WAPPING
RICK — 0705-811-541 — PORTSMOUTH	CLIVE — 881-5726 — PALMERS GREEN
PAUL — 0836-285-534 — WATFORD	LOUIS MEN — 837-0005 — ISLINGTON
PAST & PRESENT — 0923/32772 WATFORD	PAUL & DAVE — 674-3287 — BRIXTON

RECORD SHOPS

MUSIC POWER — ILFORD — 478-2080 — HARINGEY — 800-6113
RED RECORDS — BRIXTON — 274-4476 — SOHO — 734-2746
BLACK MARKET RECORDS — WEST END — 437-0478
BLUE BIRDS — SOHO — 494-1081

★ ★ ★ ★ ★

Every Rave we do we try and make it bigger and better than the last one.
We now bring you Mad For It 7, no one tries harder than Mad For It to bring you the Rave's you want to go to, so as long as you keep coming we'll keep putting on the do's.
Any ticket holder's for Sat 14th October still intact can use them at this Rave. Thank You M.F.I
Mad For It promoting with the people for the people.

As we alway's say,
Thank you all for turning up to our last Rave and we say sorry to all those who either could not find the Rave or were mislead to believing the Rave was cancelled.
We stress don't listen to rumours, phone our information lines operating on the night.
We quote (from the Daily Mirror 16th October 1989) "the one acid Rave that did go ahead was in Southbourne, Sussex when promotor's lead the police to believe the party was off, then thousands of party goers descended on the sea-side town, after being on for 12 hours the music stopped midday Sunday, it was a peaceful event and there were no arrests".

COLOURS
ALL NIGHT XMAS PARTY

Saturday 16th December '89
*to be held at a London
Film & Dance Studio*

promotion by
WORLDWIDE PRODUCTIONS

entertainment by
**frankie fonzette
noel watson
judge jules
paul anderson**

Top class sound system
with exciting light show

FOR LONDON & REGIONAL TICKET AGENTS	
01-833 8753	colin
01-423 6519	lin
01-736 8073	natasha
0860 596 032	sam (after 6)
0836 552 310	james (after 6)
01-840 7000 pager 0867 174	roy
0941 100 200 pager 108 078	paul

COLOURS
// December 1989 // Worldwide Productions
// The Dance Studios, London

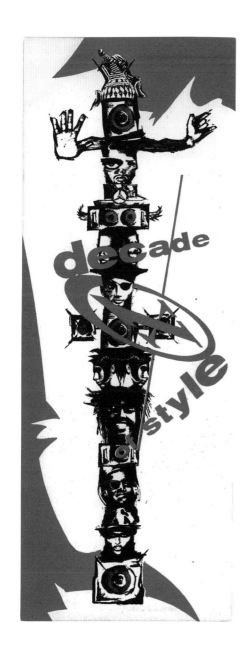

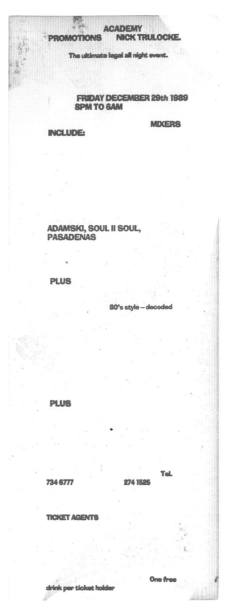

ACADEMY
PROMOTIONS NICK TRULOCKE.

The ultimate legal all night event.

FRIDAY DECEMBER 29th 1989
8PM TO 6AM

MIXERS

INCLUDE:

ADAMSKI, SOUL II SOUL,
PASADENAS

PLUS

80's style – decoded

PLUS

Tel.

734 6777 274 1525

TICKET AGENTS

One free
drink per ticket holder

DECADE OF STYLE
// December 1989 // Academy Promotions
// Central London

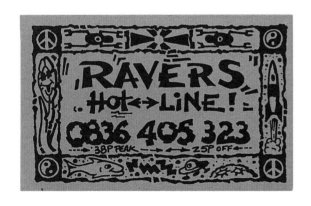

RAVERS HOTLINE
// Circa Mid 1989

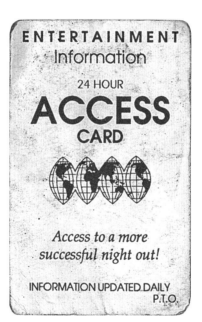

ENTERTAINMENT INFORMATION CARD
// Circa Mid 1989 // 24hr Access card
// Worldwide Productions

BIOLOGY
// December 1989
// Forward planner rave information card

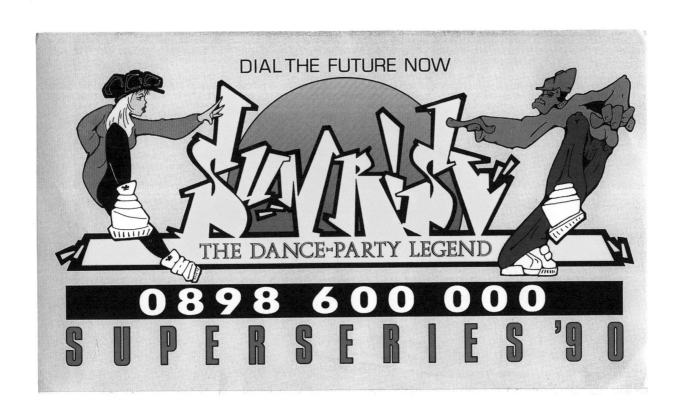

SUNRISE
// December 1989
// Superseries '90 information line

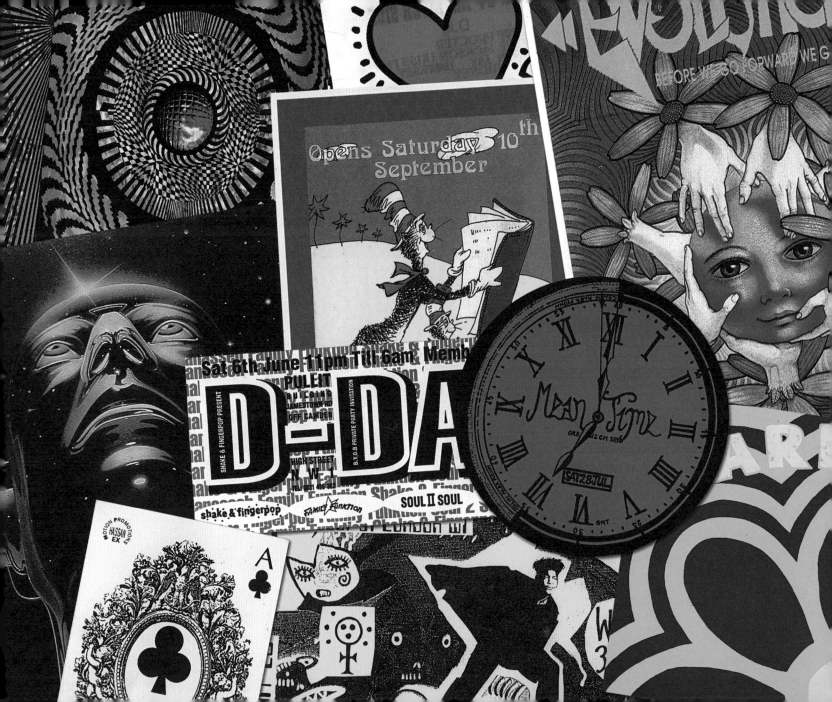

//1990

DREAMSCAPE
// February 1990 // Eternity Promotions
// The Centre, Farnham Road, Slough

EUREKA PART II
// February 1990
// The Fridge, Brixton, London SW2

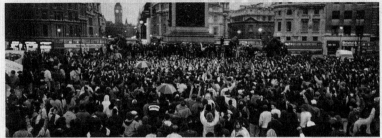

FREEDOM TO PARTY
CAMPAIGN

RALLY, SATURDAY, MARCH 3, 1990, 2.00ᴘᴍ, HYDE PARK, LONDON
SUPPORTED BY: ASSOCIATION OF DANCE PARTY PROMOTERS (ADPPro), RAVERS, RADIO STATIONS, RECORD COMPANIES AND MAGAZINES

On Saturday, January 27th, 10,000 ravers gathered to dance at Trafalgar Square in a peaceful protest against the new anti-party laws being introduced. One week later 2,000 ravers gathered in Manchester to fight for the right to party - around the country, in city after city, the protests continue...

Saturday, March 3rd sees the climax of the campaign - parliament debates the new law on March 9th. Untold thousands of ravers from around the country will gather for a national day of protest. If the new law goes through there won't be another 'Summer of Love' and there won't be any more raves, so stand up for your right to party. Show the media and the government our strength.

ARE YOU GOING TO LET THEM TAKE AWAY YOUR RIGHT TO PARTY?

CAMPAIGN INFORMATION : 0836 405411

Freedom to Party Campaign, 27 Old Gloucester Street, London, WC1N 3XX.

"ALL WE WANNA DO IS DANCE"
by
THE HOUSE CREW
featuring
M.C. JUICE
(DUE TO BE REMIXED BY ADAMSKI)

Available from the end of February...

BUY THIS RECORD TO SUPPORT THE

FREEDOM TO PARTY
CAMPAIGN

Our rooms have rhythm

FLYER BY INHOUSE PROMOTIONS 01-363-0053

FREEDOM TO PARTY CAMPAIGN
// March 1990
// Hyde Park, London W2

DECADENCE

DECADENCE

SATURDAY 10th MARCH
THE TOWN & COUNTRY CLUB · HIGHGATE ROAD · KENTISH TOWN
9.00 pm - 3.00 am
MUSIC MAKERS
BABY FORD LIVE
GURU JOSH & A MAN CALLED ADAM
DJ's ON THE NIGHT
EDDIE RICHARDS · MIKE PICKERING · ANDY WEATHERALL · IAN ROBINSON
TICKETS
£10 IN ADVANCE
TICKET OUTLETS
BLACK MARKET RECORDS 01-437 0478 · SOUL II SOUL 01-267 3995 · T&C BOX OFFICE 01-284 0303 · T&C STATION (Credit Cards) 01-284 1221
TO BE FILMED FOR FUTURE BROADCAST BY THAMES TV
FREE NIGHT BUS TO TRAFALGAR SQUARE AVAILABLE

DECADENCE
// March 1990
// Town and Country Club, Kentish Town,
London NW5

EVOLUTION
// March 1990
// Astoria, Charing Cross Road, London WC2

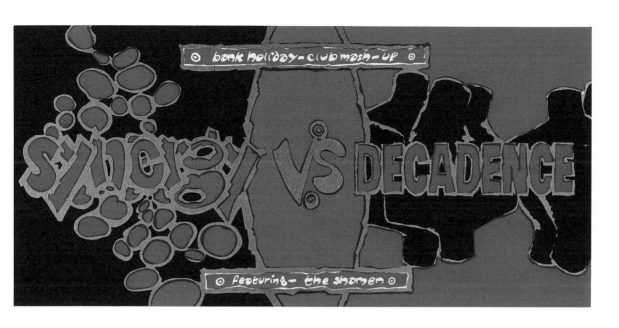

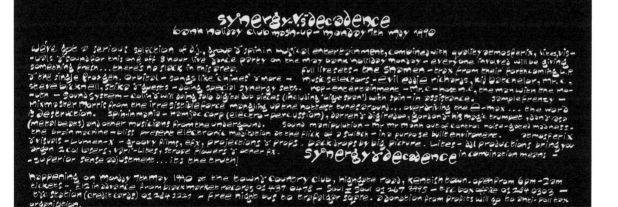

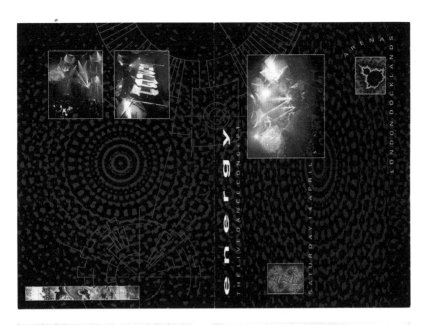

KARMA PRODUCTIONS
PROUDLY PRESENT

E N E R G Y

THE LIVE DANCE CONCEPT
AT LONDON'S DOCKLAND ARENA
ON SATURDAY 14th APRIL 1990
FROM 4.30PM TILL 11PM
FEATURING: THE FIRST EVER UK APPEARANCE OF

• BLACK BOX •

ALSO FEATURING LIVE PERFORMANCES BY

808 STATE	**SNAP**
GURU JOSH	**ADAMSKI**
ORBITAL	**THE SHAMEN**

GUEST NEW YORK D.J. AND COMPERE — FRANKIE BONES AND TOMMY MUSTO
D.J./PRODUCERS TO COMPLEMENT — D.J. LEWELEI FROM MILAN

PLUS: PAUL ANDERSON GRAEME PARK
CARL COX FABIO

SPECIAL GUEST P.A.'S BY:

DAISY D DREAM FREQUENCY
DR BAKER SUENO LATINO

BASS-O-MATIC

ARTISTS AND REPERTOIRE compiled by Tim Taylor and Colin Davie of J.S.E. - 01 730 9875

THE LIVE DANCE CONCEPT

This event will be a first in a line of new concept events. With house music becoming evermore popular Energy felt it was time to hold an event with live appearances from some of the best artists.

BLACK BOX are headlining this event with their first ever stage appearance, as well as SNAP, 808 STATE, GURU JOSH, and ADAMSKI. In addition to many up and coming acts we have a line-up of top London D.J.s, not forgetting New York's finest mixing D.J. FRANKIE BONES, who will also be the compering.

As this is the largest Energy event held so far, we are providing lighting superior to any in the past including 12 laser systems and spectacular vary light show. The decorations will create stunning visual effects using projections all around the arena, and the PA system of over 85K guarantees brilliant acoustics.

For further information on this event call the Information Line: 0836 405443.

Tickets: £16 before Thursday 12th April, £18 afterwards.

TICKET AGENTS

(There will be a booking charge on each ticket unless purchased from the new Energy Ticket Shop "FUTURE RECORDS". Call the ticket line for booking details)

LONDON TICKET OUTLETS

ENERGY TICKET SHOP (Buy 12 get 1 free/No booking charge)	01-352 0341
Fanny Records, The Garage, Kings Road, London SW6	
BLACK MARKET RECORDS	01-437 0478
25 D'Arby Street, Soho W1	
QUAFF RECORDS	01-792 0068
253 Portobello Road, W11	
SOUL II SOUL	01-267 3995
162 Camden High Street, NW1	
MASH	01-434 9809
Oxford Street, W1	
NOTE FOR NOTE	01-520 4223
5 Central Parade, Hoe Street, Walthamstow, E17	
RED RECORDS	01-274 4476
500 Brixton Road, SW9	
MUSIC POWER	01-800 6113
37 Grand Parade, Green Lane, N16	
MUSIC STATION	01-657 3994
The Basement, Kew Market, Kensington, W8	
STINGRAY RECORDS	01-670 2030
886 Norwood Road, West Norwood, SE27	
KEITH PROWSE	01-741 9909
Virgin Megastore, 14-16 Oxford Street	
OK Marble Arch, 127 Oxford Street, W1	

REGIONAL OUTLETS

SOUTH			NORTH	
POUR HOMME	301 1621		EASTERN BLOCK RECORDS	061 835 2266
71 Belgrave Road, Welling, Kent DA16 3PG			Unit 1, Afflecks Arcade, 35-43 Oldham Street, Manchester M1 1JG	
MR PRICE RECORDS	688 0278		THE DEPOT	021 643 6645
42 Station Road, Croydon			9 Piccadilly Arcade, New Street, Birmingham	
ROCKOLA	0222 341848		LOADING BAY	021 472 2460
31 Castle Arcade, Cardiff			386 Bristol Road, Selly Oak, Birmingham 29	414 1540
RECORD AND DISCO CENTRE	01-868 1637		JUMBO RECORDS	0532 455570
230 Rayners Lane, Pinner, Middlesex			102 Merrion Centre, Leeds, LS2 8PJ	
WORLD CLASS RECORDS	0206 760978		SOUL SENSE RECORDS	0582 23337
18 Church Walk, Colchester, Essex			16 Stuart Street, Luton, Bedfordshire	
SLOUGH RECORDS	0733 26898		SPIN INN	061 834 5303
Farnham Road, Slough, Berkshire, SL2			Unit 1, Paff Mall, Market Centre, Manchester	
TICKET EXPRESS	0272 441441		ARCADE RECORDS	0602 474932
204 Cheltenham Road, Bristol, BS6 5QX			West End Arcade, Nottingham, NG1 6JP	
CARNIVAL RECORDS	0202 741330		STEVE JASON TICKET AGENCY	0733 66075
24b Ashley Road, Parkstone, Poole, Dorset			10 Westgate Arcade, Peterborough	
MR PRICE RECORDS	0273 400330			
89 Trafalgar Street, Brighton				
BOOK IN NOW	0225 444410			
72 Walcot Street, Bath, Avon BA1 5BD				

TICKET AGENTS

PAUL & DAVE	01-769 3779/01-674 3287		WARREN	5100086
Brixton			Ilford	
NICK	0276 35958		RICHARD	0502 500536
W Surrey			Norfolk/Suffolk	
MARK	0932 568976		ROBERT	0462 490368
E Surrey			North Herts	
RICK	0860 469351		GREG	0206 767687
Portsmouth			Essex	0831 116 743

CREDIT CARD BOOKINGS
STAR GREEN 28 Argyll Street, W1. 01-734 8932

INFORMATION DETAILS
0836 405443

RESERVATIONS AND TICKET AVAILABILITY
0836 405427

Urgent enquiries: Karma Productions: 01-736 6390/01-384 2060
Send to: KARMA PRODUCTIONS, Bridge House, 296 Wandsworth Bridge Road, London SW6

Please send me details on all your future events.

NAME ..
ADDRESS ..
.. POSTCODE
TELEPHONE NUMBER DATE OF BIRTH SIGNATURE

ENERGY
// April 1990 // Karma Productions present // Live Dance
// Docklands Arena, London E14

THE MANHATTAN PROJECT

WITH **J.C.** AND SPECIAL **N.Y.C** GUESTS
PLAYING DEEP GROOVES AND GARAGE DOWNSTAIRS
AND **JONATHAN DAVIS**
MIXING INTERNATIONAL CLUB FAVOURITES
FRIDAY 18 MAY 1990
£10 (£7 WITH THIS INVITE)
10.30pm TO 4.30am
LIMELIGHT
136 SHAFTESBURY AVENUE LONDON W1 434 0572

NORMAN JAY

shake & fingerpop '90
PRESENTS
OLD SCHOOL WAREHOUSE
AT CAMDEN STUDIOS DINGWALLS LONDON NW1 11th MAY '90
10.00 p.m. till late. — Admission £7.00
THIS IS A MONTHLY EVENT....NEXT FINGERPOP....FRIDAY 8th June.....

FEMI BRO MARCO

THE MANHATTAN PROJECT
// May 1990 // Limelight
// Shaftesbury Avenue, London W1

OLD SCHOOL WAREHOUSE
May 1990 // Shake and Fingerpop
// Camden Studios, Dingwalls, London NW1

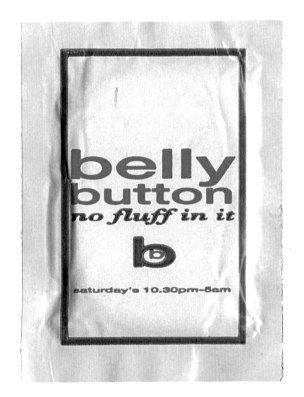

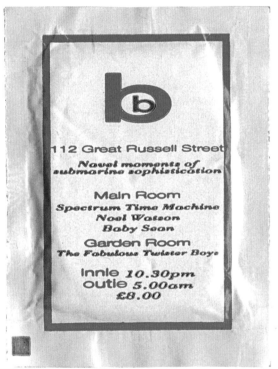

BELLY BUTTON
// Circa 1990 // BB
// Great Russell Street, London WC1

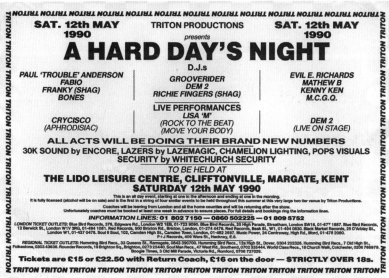

A HARD DAY'S NIGHT
// May 1990 // Triton Productions present
// Margate, Kent

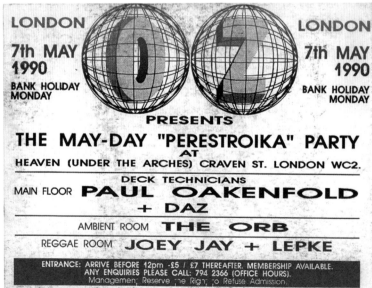

PERESTROIKA PARTY
// May 1990 // Oz presents the May-Day "Perestroika" Party
// Heaven, Villiers Street, London WC2

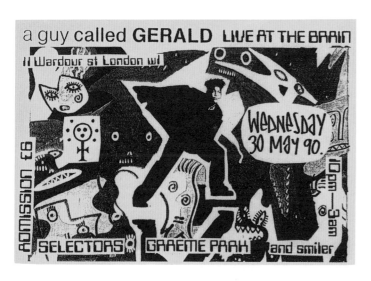

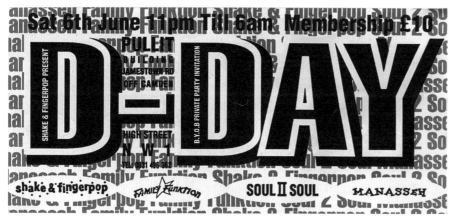

THE BRAIN
// May 1990
// Wardour Street, London W1

D-DAY
// June 1990 // Shake and Fingerpop present
// Jamestown Road, Camden Town, London NW1

MEGA LO MANIA

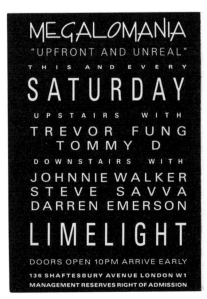

MEGALOMANIA
"UPFRONT AND UNREAL"
THIS AND EVERY
SATURDAY
UPSTAIRS WITH
TREVOR FUNG
TOMMY D
DOWNSTAIRS WITH
JOHNNIE WALKER
STEVE SAVVA
DARREN EMERSON
LIMELIGHT
DOORS OPEN 10PM ARRIVE EARLY
136 SHAFTESBURY AVENUE LONDON W1
MANAGEMENT RESERVES RIGHT OF ADMISSION

megalomania. a psychopathological condition marked by fantasies of power, wealth, or omnipotence. saturday night at the limelight. **megalomania.** a mental disorder characterized by delusions of grandeur and power. saturday night at the limelight. **megalomania.** a mental illness characterized by delusions of grandeur, power, and wealth. saturday night at the limelight. **megalomania.** a psychopathological condition marked by fantasies of power, wealth, or omnipotence. **megalomania.** saturday night at the limelight. **megalomania.** a mental disorder characterized by delusions of grandeur and power. **megalomania.** saturday night at the limelight. **megalomania.** a mental illness characterized by delusions of grandeur, power, and wealth. saturday night at the limelight. **megalomania.** a psychopathological condition marked by fantasies of power, wealth, or omnipotence. **megalomania.** saturday night at the limelight. **megalomania.** a mental disorder characterized by delusions of grandeur and power. **megalomania.** saturday night at the limelight.

MEGALOMANIA
// Circa Mid 1990 // Limelight
// Shaftesbury Avenue, London W1

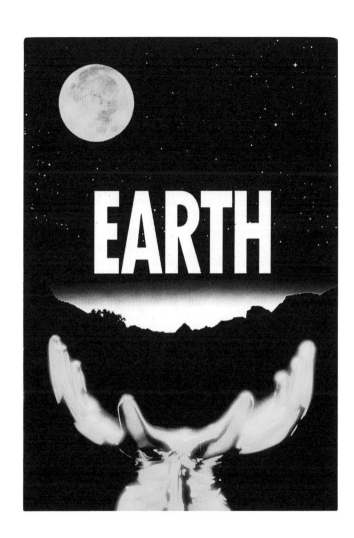

CREATION BEGINS 4 JUNE 1990

EARTH

CREATION BEGINS 4 JUNE 1990

'A GLOBAL EXPERIENCE!'

MONDAYS 10.30pm - 3.30am.
IN HEAVEN, (UNDER THE ARCHES), CRAVEN ST. WC2.

THE DECK TECHNICIANS

PAUL OAKENFOLD + D.J.- DAZ

— PLUS VERY SPECIAL GUESTS —

4th JUNE	11th JUNE	18th JUNE
PAUL "TROUBLE" ANDERSON	COLIN HUDD	CARL "III DEK" COX

THEREAFTER ROTATED EVERY THREE WEEKS, SUBJECT TO AVAILABILITY - PLEASE CHECK PRESS FOR DETAILS.

"GARDEN BAR"	"AMBIENT LOUNGE"
STEVE BICKNELL & ANDY NICHOLLS	THE ORB & GUESTS

LIVE ON STAGE

4th JUNE - The Adventures of STEVIE V
FEATURING MELODY WASHINGTON + THE FLOURMASTERS
PERFORMING: "DIRTY CASH" and "BODY LANGUAGE"

11th JUNE - JAZZ & THE BROTHERS GRIMM
PERFORMING: "CASANOVA" and "YELLOW CAN"

18th JUNE - THE MIND OF KANE

EARTH ENTRANCE

ADMISSION - ARRIVE BEFORE 12pm: MEMBERS £5
£6 THEREAFTER. GUESTS: £8
(PLEASE BRING X2 PASSPORT PHOTO'S FOR QUICK MEMBERSHIP)
FOR MEMBERSHIP DETAILS + ENQUIRIES PLEASE CALL
071 794 2366 (DURING OFFICE HOURS)

"IT'S TIME TO GET BACK DOWN TO EARTH"
THE MANAGEMENT RESERVES THE RIGHT TO REFUSE ADMISSION

EARTH
// June 1990 // 'A Global Experience!'
// Heaven, Villiers Street, London WC2

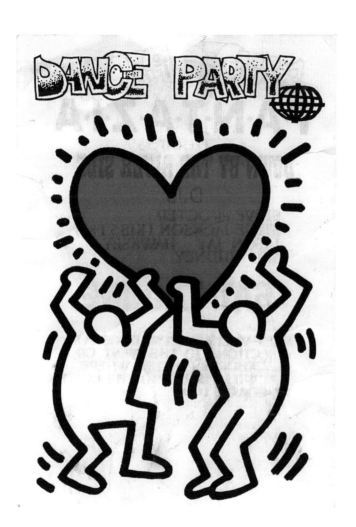

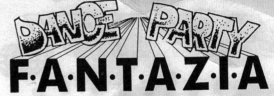

DANCE PARTY

F·A·N·T·A·Z·I·A

PRESENT

DOWN BY THE RIVER SIDE

DJs

STEVE PROCTER
STEVE JACKSON (KISS FM)
JASON JAY · HAWKSEY
AND HUDNEY

SAT 17 JUNE

MEET–WALTHAMSTOW DOGS FOR
DIRECTIONS TO THE EVENT OR
BLACKHORSE RD TUBE WHERE
YOU WILL FERRIED TO THE EVENT
BY COACH 11pm

DANCE PARTY
// June 1990 // Fantazia present // Down By The River Side
// Meeting point: Walthamstow Dogs for directions

 KARMA PRODUCTIONS

PRESENT

THE SPACE RACE

ON SATURDAY 30th JUNE 1990
AT THE DIORAMA
PETO PLACE, GREAT PORTLAND STREET, NW1

10PM — VERY LATE

DJ'S
FRANKY VALENTINE
CARL COX
FABIO

WE WILL BE DECORATING THIS DELIGHTFUL VENUE TO OUR USUAL STANDARDS. THE SOUND, LIGHTING AND MUSIC WILL BE EXCELLENT. THERE WILL ALSO BE A SPECIAL GUEST P.A. WE DO ADVISE YOU TO ARRIVE VERY EARLY AS THIS VENUE HAS A SMALL CAPACITY.

FOR FURTHER INFORMATION PLEASE CALL
0836 405443
OR CALL THE OFFICE ON 071 736 6390

THE SPACE RACE
// June 1990 // Karma Productions
// The Diorama, Great Portland Street, London W1

WORLD
// July 1990 // Eternity and DC Promotions
// The Centre, Farnham Road, Slough

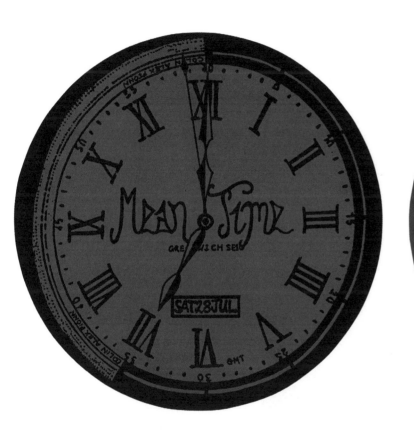

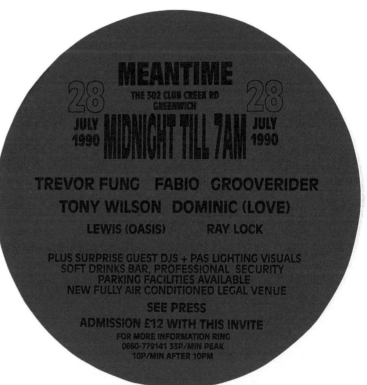

MEANTIME
// July 1990
// 302 Club, Creek Road, Greenwich, London SE10

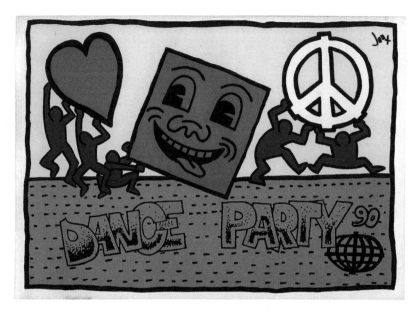

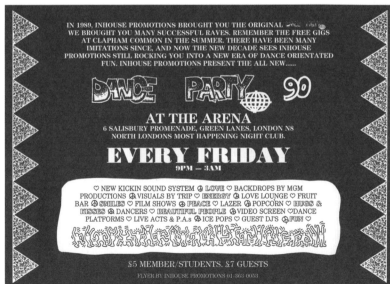

DANCE PARTY 90
// Circa 1990
// The Arena, Green Lanes, London N8

MASS ON SUNDAY

6 SALISBURY PROMENADE GREEN LANES LONDON N8.

(nearest tube Turnpike Lane/Piccadilly Line)

DANCE PARTY ALWAYS KICKS

ALSO FOR FOUR MORE SUNDAYS DANCE PARTY

BRING YOU

MASS ON SUNDAY

AT THE ARENA NIGHTCLUB

FROM 6pm to MIDNIGHT ONLY £5.

NORTH LONDONS PREMIER DANCE CLUB

PLEASE NO DRUGS

ARTWORK COURTESY OF KEITH HARING NY

DANCE PARTY
// Circa 1989/90 // Mass on Sunday
// The Arena, Green Lanes, London N8

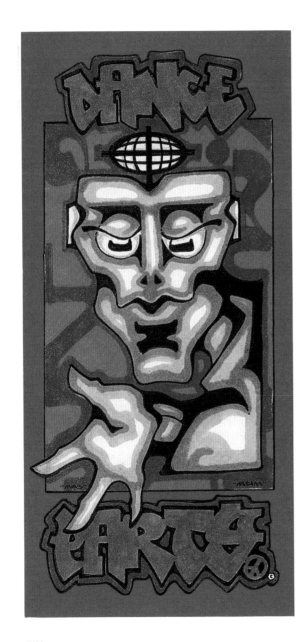

DANCE PARTY 90

AT
THE ARENA
EVERY FRIDAY

SALISBURY PROMENADE · GREEN LANES · HARINGEY N8
(Nearest Tube · Turnpike Lane · Piccadilly Line)

★ **BACKDROPS** — *Rainey* ★

★ **PROJECTORS** — *Utopia* ★

★ **LAZER** — *Spectrum* ★

DJ's
HUDNEY · DAVE HAWKES · JASON JAY · RAINEY DAZE

10pm till 3am

Members £5 ★ Guests £7 plus free membership

AND NOW
AT THE GOLDMINE

WESTERN ESPLANADE · SEA FRONT · CANVEY ISLAND

ESSEX'S TOP DANCE RAVE
★ **EVERY THURSDAY** ★

9pm till 2am

***ATTRACTIONS PLUS TOP DJ's & FRESH
YOUNG DJ's WORKING YOU UP***

★ **ENTRANCE £4** ★

FREE MEMBERSHIP AVAILABLE ON THE NIGHT

FLYER BY INHOUSE PROMOTIONS TEL: 01-363 0053

DANCE PARTY 90
// Mid-1990
// The Arena, Green Lanes, London N8 and
Now at the Sea Front, Canvey Island, Essex

KARMA PRODUCTIONS
PROUDLY PRESENT

ENERGY
LIVE DANCE
PART II

ALL
STANDING

AT LONDON'S DOCKLAND ARENA
ON SATURDAY 4th AUGUST 1990
FROM 5PM TILL 11PM
(Doors open at 3pm please arrive early)
HEADLINED BY

ALL
STANDING

• REBEL MC •

ALSO FEATURING LIVE PERFORMANCES BY

D SHAKE	BBG
WEST BAM	LFO
TOGETHER	MR MONDAY
KICKING BACK WITH THE TAX MAN	

DJ'S

MIKE PICKERING	CARL COX
JAZZY M	FABIO

ENERGY PART II

After the success of the last Docklands, we are proud to present Energy Part II. Energy has gone from strength to strength using house names with worldwide recognition. After the incredible line up in April including major chart successes such as Black Box, Adamski and Snap we are pleased to announce that we have Rebel MC headlining this event with D-Shake, BBG, and special guest P.A.'s from West Bam, LFO, Mr Monday, Together, Kicking Back with the Tax Man. The d.j.'s will be Fabio, Mike Pickering, Carl Cox, Jazzy M and many more. This event will be all standing so you can dance away with an electric atmosphere created with a spectacular lighting display with varilites, lasers, projections and decorations to the highest Energy standards, including an 85K sound system.

As you will notice there has been a small increase in the price of tickets. This is due to a reduction in numbers to enable all ticket holders to stand and dance rather than being confined to your seat.

Details will be confirmed regarding any further attractions and more confirmed acts and d.j.'s by ringing

0836 405443.

Tickets: £19 before Monday 30th July, £21 afterwards.

(All tickets are subject to a booking charge except from the Energy Shop.)

INFORMATION LINE
0836 405443
TICKET AGENTS
(There will be a booking charge on each ticket unless purchased from the Energy Ticket Shop.
Call the ticket line for booking details)

LONDON TICKET OUTLETS

ENERGY TICKET SHOP (Buy 12 get 1 free/No booking charge)	0836 405427
The Garage, Kings Road, Chelsea SW3	
BLACK MARKET RECORDS	071-437 0478
25 D'Arby Street, Soho, W1	
MI PRICE RECORDS	071-367 3995
162 Camden High Street, NW1	
MASH	071-434 9689
Oxford Street, W1	
NOTE FOR NOTE	081-520 4223
3 Central Parade, Hoe Street, Walthamstow, E17	
RED RECORDS	071-274 4476
500 Brixton Road, SW9	
MUSIC POWER	081-800 6113
17 Grand Parade, Green Lane, N14	
KEITH PROWSE	081-741 8989
Virgin Megastore, 14-16 Oxford Street	
Off Marble Arch, 127 Oxford Street, W1	

REGIONAL OUTLETS

SOUTH		NORTH	
POUR HOMME	081-301 1625	EASTERN BLOCK RECORDS	061 835 2366
71 Belgrave Road, Welling, Kent		Unit 1, Affleck Arcade, 35-43 Oldham Street, Manchester M1 UG	
MI PRICE RECORDS	081-688 0279	THE DEPOT	021 643 6045
42 Station Road, Croydon		9 Piccadilly Arcade, New Street, Birmingham	
RECORD AND DISCO CENTRE	081-868 8637	SOUL SENSE RECORDS	0582 25337
330 Rayners Lane, Pinner, Middx		16 Stuart Street, Luton, Bedfordshire	
WORLD CLASS RECORDS	0206 768970	SPIN INN	061 834 5391
18 Church Walk, Colchester, Essex		Unit 1, Pall Mall, Market Centre, Manchester	
SLOUGH RECORDS	0753 28394	STEVE JASON TICKET AGENCY	0733 60075
Farnham Road, Slough, Berks		10 Westgate Arcade, Peterborough	
TICKET EXPRESS	0272 441440	CARNIVAL RECORDS	0202 741230
204 Cheltenham Road, Bristol, BS6		246 Ashley Road, Parkstone, Poole, Dorset	
MI PRICE RECORDS	0273 698330		
95 Trafalgar Street, Brighton			

TICKET AGENTS

PAUL & DAVE	081-769 5779	WARREN	081-518 0086
Brixton		Ilford	
RICHARD	0502 500536	ROBERT	0462 490368
Norfolk/Suffolk		North Herts	
GREG	0206 871124	IMMENSITY	081-947 1791
Essex	0831 116743	South London	

CREDIT CARD BOOKINGS
STAR GREEN 20 Argyll Street, W1. 071-734 8932
INFORMATION DETAILS
0836 405443
RESERVATIONS AND TICKET AVAILABILITY
0836 405427
Urgent enquiries: Karma Productions: 071-736 6390 Fax: 071-384 2060
Send to: KARMA PRODUCTIONS, Bridge House, 296 Wandsworth Bridge Road, London SW6 2UA

Please send me details on all your future events.
NAME ...
ADDRESS ...
.............................. POSTCODE...........................
TELEPHONE NUMBER DATE OF BIRTH SIGNATURE

ENERGY
// August 1990 // Karma Productions present // Live Dance Part II
// Docklands Arena, London E14

PERCEPTION
// August 1990
// Stan Stan Promotions // M25

LIVING LARGE

THURSDAY

AT

SUBTERANIA

ROLLING ROCK
Extra Pale
PREMIUM
BEER
IMPORTED

STARTING 27th Sept,1990
12 ACKLAM ROAD, LONDON W10

LIVING LARGE
// September 1990
// Subterania, Acklam Road, London W10

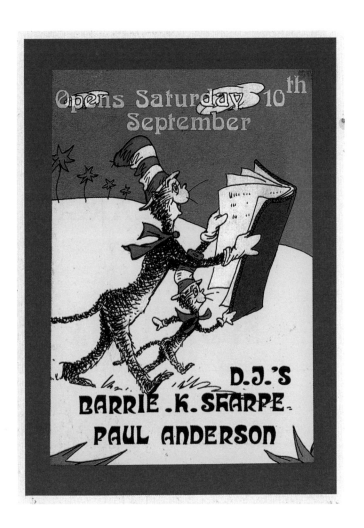

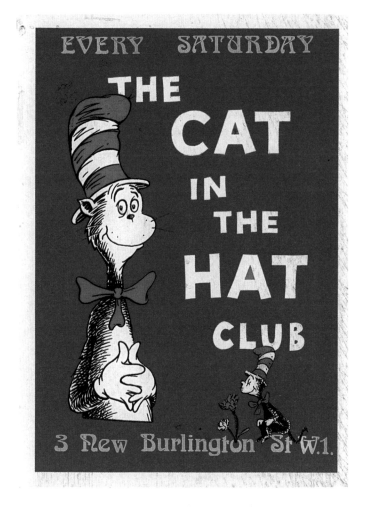

THE CAT IN THE HAT
// September 1990
// New Burlington Street, London W1

DESIDERATA

DANCE MUSIC
Past - Present - Future

Friday, 12th October 1990

at

The HYLIFE

corner of Stroud Green Road
& SevenSisteres Road

Finsbury Park

from 9.00p.m. to 2 a.m.

Doors close at 1 a.m.

Licenced Bar

Admission: £3.00 before 10.30 p.m.
£5.00 after 10.30 p.m.

The Management reserve the right of admission

DESIDERATA
// October 1990
// The Hylife, Stroud Green, Finsbury Park, London N4

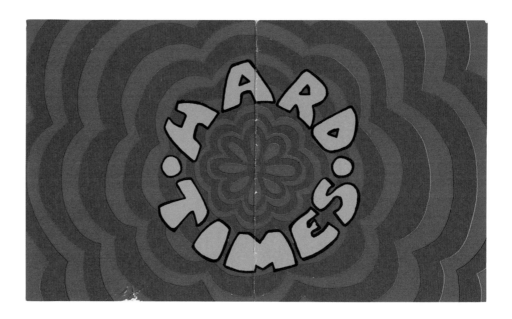

HARD TIMES
// October 1990
// Ashwin Street, Dalston, London E8

JELLY IN THE FRIDGE *Complimentary*

EVERY THURSDAY 10-3am £4 before 11 £5 after

THURSDAY 8th NOVEMBER 1990
PA

A HOMEBOY
A HIPPIE and a FUNKI DREDD

DJ's JON COX, NILS HESS, IAN B

Jelly in The Fridge visuals courtesy of Paul Bancroft, Stakker, Gary Hitch.

THE FRIDGE
Brixton, London SW2 1RJ
071-326 5100

JELLY IN THE FRIDGE
// November 1990 // A Homeboy, A Hippie and a Funki Dredd present
// The Fridge, Brixton, London SW2

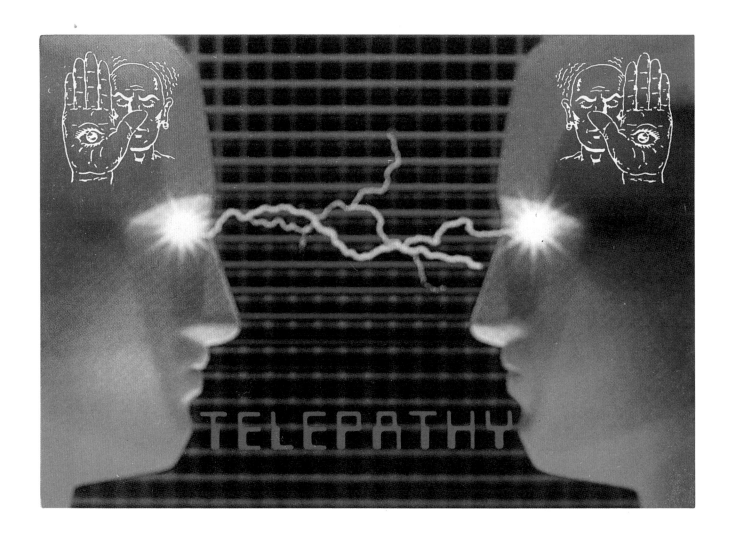

TELEPATHY
// November 1990 // Sting Productions
// Bow Flyover, London E15

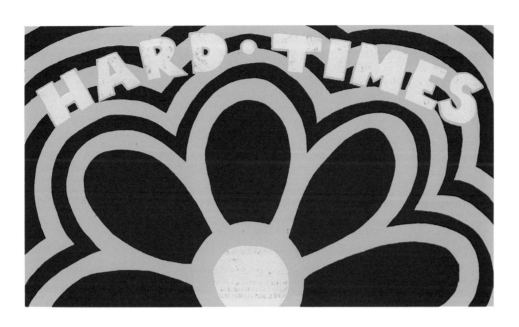

HARD TIMES

Sat 1st Dec 1990 • • 10 - 16 Ashwin St. Dalston E.8. • • 10.00pm - 6am

THE MUSICAL EXPERIENCE IS BACK, GETTING HARDER AND WILDER ON TWO FLOORS OF PURE MAYHEM. PLAYING THE TOUGHEST MUSIC IN LONDON, ALL DESIGNED TO ENLIGHTEN YOUR MIND, BODY AND SOUL.

ON THE UPPER LEVEL
HARD CORE HOUSE & MANIC BLEEPS
SUPPLIED BY:

FABIO / GROOVERIDER
LSD
M & M
DJ FX

ON THE LOWER LEVEL
A WICKED MELTDOWN OF THE BEST
ALTERNATIVE DANCE GROOVES
WITH DJ'S

GILES PETERSON
JASPER THE VINYL JUNKIE
ROY CEE

LIVE MUSICAL OVERDUBS performed by **PHILIP BENT** (Flute), **TOBY** (Adamski's Percussionist) AND **YUL** (Acoustic Guitar). **LIVE MC** on the night **YOUNG G**

TICKETS £10.00 IN ADVANCE FROM:
BLACK MARKET RECORDS • 25 D'Arbley St. W1.
PASSION RECORDS/MASH • 73 Oxford St. W1
SIGN OF THE TIMES • Kensington Market
THE VINYL ZONE • 112 New Kings Rd. SW6

DUE TO THE SUCCESS OF HARD TIMES EVENTS WE STRONGLY ADVISE
YOU TO PURCHASE YOUR TICKETS IN ADVANCE AS THERE WILL ONLY
BE A LIMITED NUMBER ON THE DOOR.

2 BARS • DANCE PLATFORMS • VISUALS BY BIG PICTURE • LIGHTING WIND MACHINE & EFFECTS BY HARD CORE • 20K OF PURE TURBOSOUND PROVIDED BY
CHANNEL 1 SOUND SYSTEM
INFORMATION LINES: 0831-243 488 • 0831-360 553

HARD TIMES
// December 1990
// Ashwin Street, Dalston, London E8

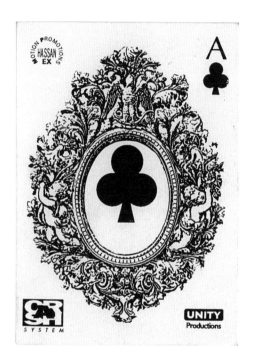

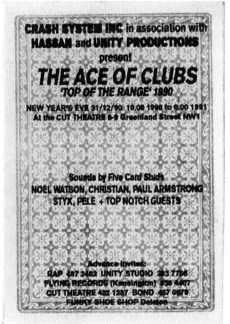

THE ACE OF CLUBS
// December 1990 // New Year's Eve Party // 'Top of the Range 1990'
// Cut Theatre, Greenland Street, London NW1

LAND OF OZ
// December 1990
// Heaven, Villiers Street, London WC2

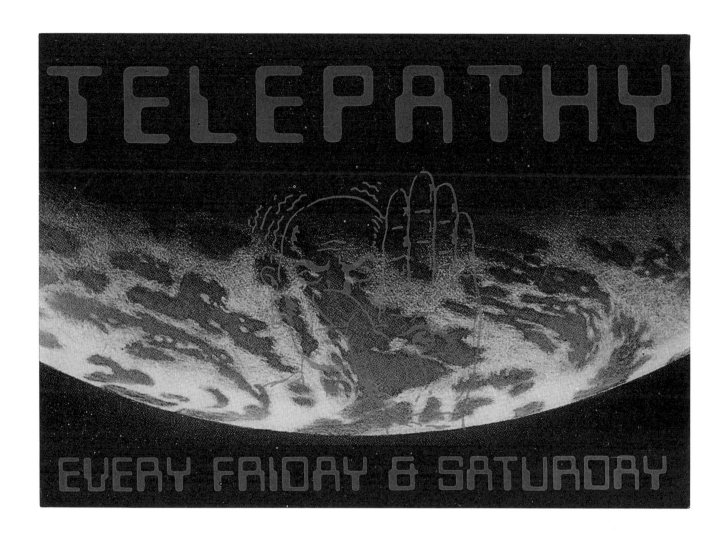

TELEPATHY
// December 1990 // Sting Productions
// Bow Flyover, London E15

//TRACKS THAT MADE THE PARTY JUMP

//CHELSEA LOUISE BERLIN

1 // MARSHALL JEFFERSON – 'MOVE YOUR BODY'

2 // MR. FINGERS/FINGERS INC – 'CAN YOU FEEL IT'

3 // RAZE – BREAK 4 LOVE

4 // FRANKIE KNUCKLES – 'YOUR LOVE'

5 // PHUTURE – 'ACID TRACKS'

6 // BYRON STINGILY – 'JUST A LITTLE BIT'

7 // FRANKIE KNUCKLES/JAMIE PRINCIPLE – 'BABY WANTS TO RIDE'

8 // THE HOUSE MASTER BOYZ AND THE RUDE BOY OF HOUSE – 'HOUSE NATION'

9 // HUMANOID – 'STAKKER HUMANOID'

10 // A GUY CALLED GERALD – 'VOODOO RAY'

11 // STEVE ''SILK'' HURLEY – 'JACK YOUR BODY (CLUB YOUR BODY)'

12 // ADONIS – 'LOST IN THE SOUND (LOST MIX)'

13 // ROBERT OWENS – 'BRING DOWN THE WALLS'

14 // LIL LOUIS – 'FRENCH KISS'

15 // INNER CITY – 'GOOD LIFE'

16 // THE TODD TERRY PROJECT – 'WEEKEND'

17 // RALPHI ROSARIO – 'YOU USED TO HOLD ME'

18 // FARLEY "JACKMASTER" FUNK & JESSIE SAUNDERS – 'LOVE CAN'T TURN AROUND'

19 // DANCER – 'NUMBER NINE'

20 // JOE SMOOTH – 'PROMISED LAND'

21 // GEORGE KRANTZ – 'DIN DAA DAA'

22 // INNER CITY – 'BIG FUN'

23 // TEN CITY – 'THAT'S THE WAY LOVE IS'

24 // SOUL II SOUL – 'KEEP ON MOVIN''

25 // 808 STATE – 'LET YOURSELF GO'

26 // BANG THE PARTY – 'RELEASE YOUR BODY'

27 // PIERRE'S PFANTASY CLUB – 'DREAM GIRL'

28 // HITHOUSE – 'JACK TO THE SOUND OF THE UNDERGROUND'

29 // LNR – 'WORK IT TO THE BONE'

30 // PHUTURE – 'THE CREATOR'

31 // FAST EDDIE – 'JACK TO THE SOUND'

32 // THE NIGHT WRITERS – 'LET THE MUSIC (USE YOU)'

33 // MARRS – 'PUMP UP THE VOLUME'

34 // ON THE HOUSE – 'RIDE THE RHYTHM'

35 // JUNGLE BROTHERS – 'I'LL HOUSE YOU'

36 // ORANGE LEMON – 'DREAMS OF SANTA ANNA'

37 // DOUG LAZY – 'LET IT ROLL'

38 // STETASONIC – 'ALL THAT JAZZ'

39 // JOLLY ROGER – 'ACID MAN'

40 // YOUNG MC – 'BUST A MOVE'

41 // SOUL II SOUL – 'BACK TO LIFE'

42 // D-MOB FEATURING LRS – 'IT'S TIME TO GET FUNKY'

43 // BOMB THE BASS – 'BEAT DIS'

44 // TWIN HYPE – 'FOR THOSE WHO LIKE TO GROOVE'

45 // BAM BAM – 'GIVE IT TO ME'

46 // KARIYA – 'LET ME LOVE YOU FOR TONIGHT'

47 // E-ZEE POSSEE – 'EVERYTHING STARTS WITH AN 'E''

48 // RHYTHIM IS RHYTHIM – 'STRINGS OF LIFE'

49 // CE CE ROGERS – 'SOMEDAY'

50 // PHASE II – 'REACHIN''

BIBLIOGRAPHY/INFORMATION FROM:
LISTOLOGY.COM
FANTAZIA.ORG.UK
WIKIPEDIA
THESITE.ORG
HARCOREWILLNEVERDIE.COM